IMAGES
of America

WASHINGTON'S
HIGHWAY 99

IMAGES
of America

WASHINGTON'S
HIGHWAY 99

Chuck Flood

ARCADIA
PUBLISHING

Published by Arcadia Publishing
Charleston, South Carolina

Printed in the United States of America

Library of Congress Control Number: 2012940996

For all general information, please contact Arcadia Publishing:
Telephone 843-853-2070
Fax 843-853-0044
E-mail sales@arcadiapublishing.com
For customer service and orders:
Toll-Free 1-888-313-2665

Visit us on the Internet at www.arcadiapublishing.com

*To Debbie, for proofreading and helping the narrative flow,
and for indulging my interest in Roadside America*

CONTENTS

ACKNOWLEDGMENTS

This project would not have been as much fun without the assistance and enthusiastic support of a number of individuals to whom credit is gratefully given:

Cheri Ryan and Kevin Stadler, Alderwood Manor Heritage Association (AMHA)
Bill Watson, Cowlitz County Historical Museum (CCHM)
Greg Knutson and Kevin Hall, Greater Des Moines-Zenith Historical Society (DMHS)
David Dilgard, Everett Public Library, Northwest History Room (EPL)
Nancy McKay, Highline Historical Society (HHS)
Barbara Barney, Historical Society of Federal Way (HSFW)
Jack O'Donnell Collection (JCO'D)
Johanna Jones and Margaret Shields, Lewis County Historical Museum (LCHM)
Carolyn Marr, Museum of History and Industry (MOHAI)
Ron Edge Collection (RKE)
Vicki Stiles, Shoreline Historical Museum (SHM)
Anne Frantilla, Seattle Municipal Archives (SMA)
Jeannette Voiland, Seattle Public Library, Seattle Room (SPL)
The Jacks Collection (TJC)
Robert Schuler, Tacoma Public Library, Northwest Room (TPL)
Jeff Jewell, The Whatcom Museum (WM)
Phil Stairs, Washington State Archives Puget Sound Regional Branch (WSA-PSR)
Craig Holstine, Washington Department of Transportation (WSDOT)
Joy Werlink, Washington State Historical Society (WSHS)
The Estate of Walter Victor Shannon (WVS)

Images not individually credited are from the author's personal collection. Images with credit lines are courtesy of the organization or individual whose abbreviation appears in the above list, which should be used to determine the contributor's full name.

INTRODUCTION

Good roads arrived late in western Washington. Climate and topography had a lot to do with it—the region has a well-deserved reputation for being wet. Water falls from the sky as rain and snow; water courses down a dozen major rivers and countless streams; water laps the coastlines of the Pacific Ocean and Puget Sound.

This abundance of moisture is largely due to the storms that charge in from the Pacific only to run head-on into the Cascade and Olympic Mountains, causing them to discharge their loads. The Olympics (and the Willapa Hills to their south) hug the coast and receive the brunt of the rainfall, but enough makes it past the first barrier to insure that the 100-mile-wide swath of land between the Olympics and the Cascades is well watered. That, in turn, creates ideal conditions for lush vegetation.

The combination of the three—water, mountains, and forest primeval—shaped where people lived and how they moved around. People traveled by water, looking to the lakes, streams, and bays to provide food and other resources. Overland travel was inhibited by tall trees and thick underbrush.

The original inhabitants by and large made their settlements along watercourses. Early white settlers followed the same pattern. Virtually all of the newcomers' settlements—Vancouver, Tumwater, Tacoma, Seattle—were on the edges of watercourses. The mountains, though explored for minerals, remained a barrier to west–east travel.

With establishment of sawmills in the 1850s, the area's early economy became timber-based. Tall trees were felled and dragged to the nearest waterway for transport to mills. As the trees were cut, open spaces appeared; soon the stumplands were being claimed for homesteads. Farming began to take hold. As more people moved away from the shores of the largest watercourses, new settlements developed to serve them. Construction of railroads in the decades following 1870 hastened development.

At the turn of the century, western Washington's transportation infrastructure, by which cities and towns located on waterways or railroad lines (as well as a myriad of small villages) connected to the rails and to each other, was made up of a network of primitive roads. The few roads leading from waterside communities to inland villages and farms were often impassible in the wet season. In 1905, there were fewer than 1,100 miles of road in the state, and of those only 124.5 miles were classified as "improved."

Then came the automobile. Initially just a toy for the rich and adventurous, automobiles became popular and increasingly affordable: in 1900, there were only 8,000 automobiles registered in the entire country; by 1930, more than 23 million cars and an additional 3.5 million trucks were on the nation's roads. Travel for its own sake; travel for fun and excitement; and travel to places that people now realized were in their own, now larger back yards, became fashionable. Tourism was born.

The existing system of roads was soon found to be unworkable. Many of the early "highways" simply followed the routes of the wagon roads that preceded them; barely passable at times even for horses, they often got from Point A to Point B via Points C, D, X, and Y.

Demands for getting from place to place faster and more directly soon led to major highway-building programs. "Good roads" became a rallying cry for the new breed of travelers. By 1910, recognizing that virtually all of the early roads were intended for wagons and other animal-drawn vehicles, the state began to plan a new roadway system for automobile traffic.

In 1911, the state legislature passed the Permanent Highway Act, which transferred more road-building responsibility to the state and authorized the construction of hard-surface roads to enhance commercial transportation. In 1912, the Good Roads Association joined the effort to improve Washington highways and proposed three major "trunk" routes in the state: the Sunset Highway, the Pacific Highway, and the Inland Empire Highway.

By decree more than by action, the Pacific Highway became the primary north–south trunk road in the western part of the state, connecting Washington with Oregon and British Columbia. In its original configuration, the Pacific Highway was 310 miles in length through the state, usually following pre-existing roads. Gradually, bypasses and improvements were constructed, though paving for the entire stretch of the highway through Washington was not completed until 1923.

At that time, the Pacific Highway was officially renamed Primary State Road No. 1, although it remained popularly known as Pacific Highway. Major portions of the Pacific Highway were realigned and newly constructed between 1926 and 1927. At the same time, the practice of naming US highways began to give way to the assignment of numbers; the Pacific Highway became US Highway 99, though alternate designations for the route continued to be used (and still are today).

By the mid-1920s, the quality of the roads had dramatically improved, but outside the major cities and towns, services for motorists were still few and far between. An obvious business opportunity existed—after all, the new breed of travelers needed places to eat and sleep; their automobiles needed gas, water, and service; and they all needed to see such wonders as waterfalls, tall trees, and two-headed calves.

A new generation of entrepreneurs embraced the opportunities. Roadside restaurants and cafés, tourist parks, auto courts and motels, and gas stations sprang up along the highway. Typically single-owner enterprises (at least in the formative years), they often bore the owners' names ("Bessie B's Lunch") or took their names from local scenic, historical, or mythological entities ("White River Lodge," "Lewis Clark Hotel," "Twin T-Ps"). They followed no standardized design beyond the obvious requirements that motel rooms have doors and restaurants have chairs and tables. Each structure was different; in many instances, the combination of design, color, and setting approached folk art in style. Over the years, nearly 1,300 "gas, [food, and] lodging" businesses lined Highway 99. Among them were restaurants shaped like igloos or tepees, or made out of giant redwood logs, as well as a gas station that looked like a cowboy hat and boots

By the end of the 1950s, it was all coming to a close. The country embarked on a massive project—the interstate freeway system. Freeways changed America. A new model developed for how people traveled and how services were provided to them. With limited access and a policy of avoiding (as much as possible) the centers of towns, freeways bypassed the hearts of the cities and towns along their route by keeping to the edges where land was cheap and there were fewer people to displace. Old, established, traveler-oriented businesses located along the old highway or in bypassed downtowns could not compete. Some tried; many failed. New businesses sprang up at the access points to the freeways.

US 99 was decertified in 1968 with completion of the freeway system. In Washington State, much of the old highway was renumbered State Route 99, though many portions of the highway are still called by their historical names. With the exception of a few stretches where it is necessary to get on the freeway, Highway 99 can still be driven from border to border. Unfortunately, only a fraction of the roadside businesses pictured in this book survive in their original form; most have disappeared.

One

BLAINE TO EVERETT

Highway 99 originates in Vancouver, British Columbia, and runs 45 miles across the Fraser River floodplain to merge with Interstate 5 at the international border at Blaine, Washington. In early times, the route from Vancouver followed BC Highways A (the Fraser River Highway) and R to a border crossing a mile northeast of Blaine. After entering the US, the route became the Pacific Highway. Turning south and west to Blaine, it passed through the business district and followed a zigzag route over local roads toward Ferndale and Bellingham. The early crossing, called the Truck Crossing, is still in use as an alternate to the main Peace Arch checkpoint.

The Peace Arch commemorates the centennial (1814–1914) of the Treaty of Ghent ending the war of 1812; it was dedicated in 1921. An earlier Peace Arch, constructed of logs in 1915 at the original border crossing, did not survive the weather. The Peace Arch became the main crossing point in the 1930s when the highways in Washington and British Columbia were realigned.

Traversing farmlands on its way to Bellingham, the Pacific Highway passed through Custer and Ferndale; both towns were left off the route when the highway south of Blaine was straightened out in the 1930s. Bellingham was the first large city south of the border, offering full services to motorists. Travelers left Bellingham via Chuckanut Drive: a scenic, two-lane road designated the Pacific Highway in 1913 and Highway 99 in 1926. With construction of a direct route out of Bellingham to Burlington in 1931, Chuckanut Drive became Highway 99-A.

Highway traffic edged Burlington and passed through Mount Vernon. At Conway, the original route headed south to Marysville via Stanwood and Silvana. Another 1930s bypass between Conway and Marysville left the two towns miles off the main route.

South of Marysville, a series of bridges carried Highway 99 across the main channel and sloughs of the Snohomish River and into Everett. Called the "Marysville Cut-off," it eliminated several miles (often muddy and barely passable) of circular travel east from Marysville, then back west to Everett.

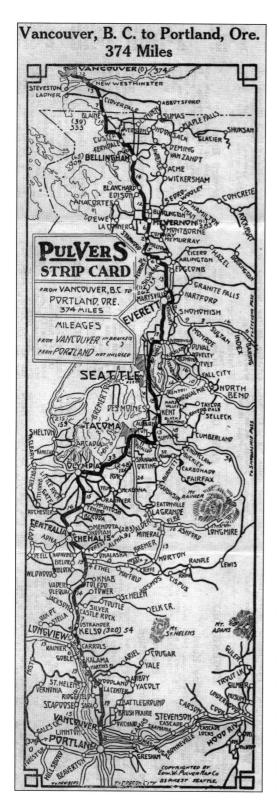

Vancouver, B. C. to Portland, Ore.
374 Miles

PulVerS STRIP CARD

FROM VANCOUVER, B.C. TO PORTLAND, ORE.
374 MILES

MILEAGES
FROM VANCOUVER IN BRACKETS ()
FROM PORTLAND NOT INCLOSED

COPYRIGHTED BY
Edw. W. Pulver Map Co
83 PIKE ST SEATTLE.

In the days before road atlases and GPS navigation devices, motorists relied on maps like this to find their way around. This "strip card," issued by the Edward W. Pulver Map Company of Seattle, depicts an early alignment of the Pacific Highway. It probably dates to the early 1920s, since major highway improvements completed in 1926 and 1927—the Seattle-Everett and Seattle-Tacoma Highways—are not shown. Many towns on this map, such as Ferndale, Stanwood, and Silvana, were bypassed by the new highways. Even the burgeoning cities of Kent and Auburn, south of Seattle, were left off the route of the new Pacific Highway by the 1926 construction. Today's Interstate 5 freeway parallels, overlaps, and in some places obscures the original route, though much of the old highway can be driven.

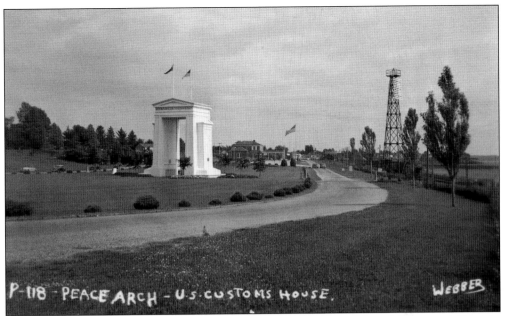

The Peace Arch marks the international boundary between the United States and Canada. Built in 1921 with the support of Sam Hill, a champion of the Good Roads Movement, the arch commemorates the 1814 Treaty of Ghent, which ended the War of 1812. Originally not on the Pacific Highway, the route was realigned to curve around the Arch by 1940.

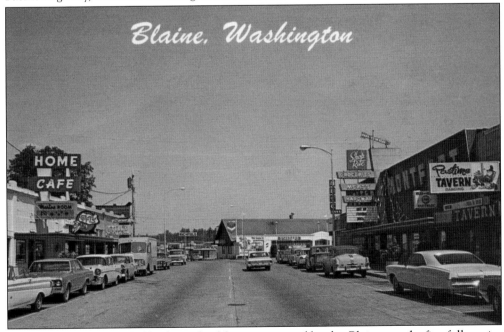

Downtown Blaine sits a half mile south of the international border. Blaine was the first full-service stopping point on Highway 99 south of Vancouver (or the last, if traveling north). This view shows some of the many businesses that developed to attract travelers: cafés, gas stations, taverns, and gift shops. Interstate 5 bypassed Blaine in the 1960s, but being a major point-of-entry gives the town economic stability. (JCO'D.)

11

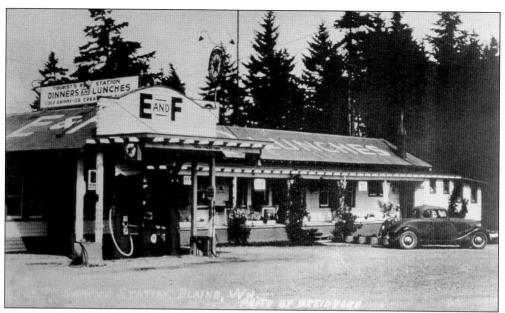

E and F Service, in Blaine, would have been one of the first roadside businesses that the southbound traveler encountered on the early Pacific Highway. The E and F could provide practically everything the tourist needed—lunches, dinners, gasoline, and restrooms. The long covered porch would have been an inviting place to sit and watch traffic pass while enjoying an ice cream cone. (WM , 1999.0005.000108.)

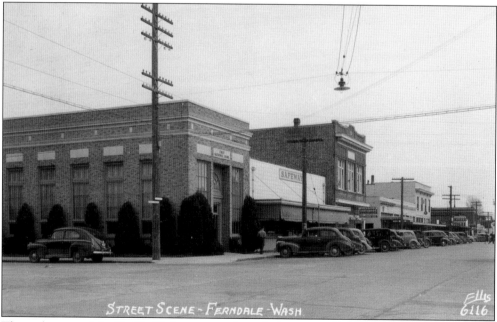

The early route of the Pacific Highway went through downtown Ferndale; the 1931 realignment of Highway 99 passed three-fourths of a mile to the east of town. Though off the main route, motorists undoubtedly made the short detour into town to stock up on supplies and services. A First National Bank and Safeway grocery store are prominent on Main Street; a Texaco station can be seen farther up the road.

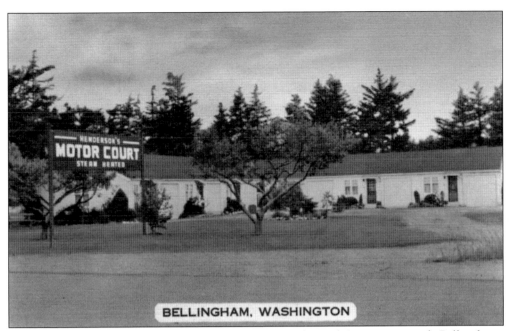

BELLINGHAM, WASHINGTON

Henderson's Motor Court was located at 2622 W Maplewood Avenue in north Bellingham. Owner-operators Mr. and Mrs. M.E. Henderson opened the motel about 1940 in a residential neighborhood; within a few years, four gas stations and several other tourist courts sprang up in the area to attract southbound travelers approaching the city. Henderson's was "modern and fireproof," with private baths, electric kitchens, and locked garages.

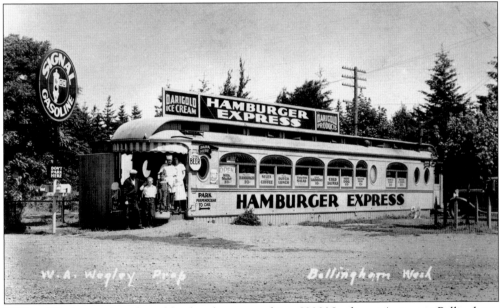

William Wegley purchased an old railroad car, moved it to 3300 Northwest Avenue in Bellingham, converted it to a diner, and opened the Hamburger Express in 1935. A full menu was offered, including an "Aristocratic Hamburger" for 10¢. A cabin camp operated in connection with the diner. By 1940, Jack Martin, Wegley's cook, had taken over the Hamburger Express. It was gone by 1948. (WM, 1999.0020.000009.)

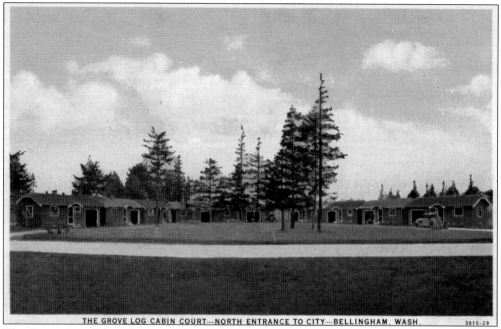

The Grove Log Cabin Court was located at 3219 Northwest Avenue, at that time the north entrance to Bellingham. Built around 1927 and managed by the Strandberg brothers, the Grove consisted of nine units arranged in a semicircle facing the Pacific Highway, each unit constructed of peeled logs and having a central doorway and covered garage. By 1948, the name had been changed to Northwest Auto Court.

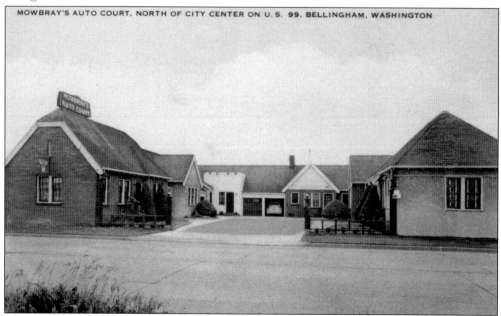

MOWBRAY'S AUTO COURT, NORTH OF CITY CENTER ON U.S. 99, BELLINGHAM, WASHINGTON

Clarence E. Mowbray's Auto Court opened at 3005 Northwest Avenue around 1947. The motel contained seven sturdy brick units, some with covered garages, ranging in price from $5 to $7 per night. Note the fine castellated ornamentation above the office door. The building has changed little over the years; it is now called the Colonial Court Apartments.

14

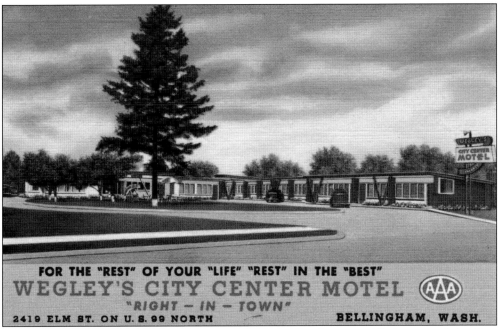

After William Wegley sold his auto court on Samish Way (see page 20), he opened the City Center Motel at 2419 Elm Street in 1952. The motel's low profile blended into the predominately residential neighborhood. Each unit had a combination tub and shower, private phone, refrigerator, radio, and bed lamps; some had kitchens. In later years, the City Center was owned by Mr. and Mrs. G.R. DeNise.

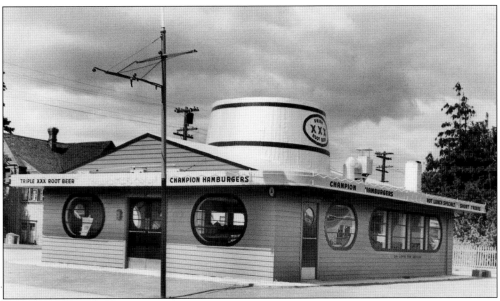

This Triple XXX Barrel, at 1114 Dupont Street in Bellingham, was the first of many giant root beer barrels that the southbound traveler would encounter along Highway 99. The restaurant opened in 1936 under Marvin T. Cook. In 1955, it was owned by LeRoy Cyr and still going strong. Fish and chips and short orders, including a Champion Burger, were among the menu choices. (WM, 1980.0074.000324.)

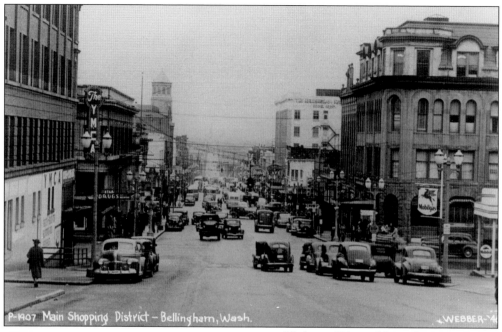

P-1907 Main Shopping District - Bellingham, Wash. WEBBER

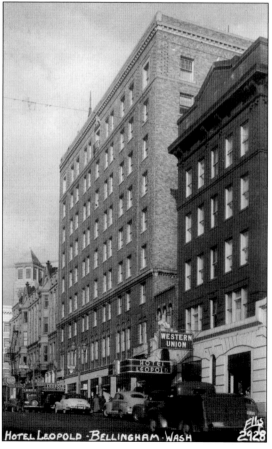

HOTEL LEOPOLD - BELLINGHAM - WASH Ellis 2928

Highway 99's southbound route through Bellingham followed a series of shallow right turns along Maplewood and Northwest Avenues and Elm, Dupont, Prospect, Holly, Ellis, and Maple Streets to Samish Way and out of the city. This 1946 view shows Holly Street, a principal business thoroughfare, crowded with people and automobiles. A Mobilgas station is visible at right. Note that the street has no painted lane dividers. (JCO'D.)

The elegant Hotel Leopold was half a block off the Pacific Highway at 1224 Cornwall Avenue in downtown Bellingham. Over the years, the Leopold underwent periodic upgrades and expansions, providing 265 rooms to tourists at reasonable rates: singles from at $1.50 and doubles from at $2. A dining room, coffee shop, and fountain operated in connection with the hotel; the Leopold Storage Garage and service station were down the street. (JCO'D.)

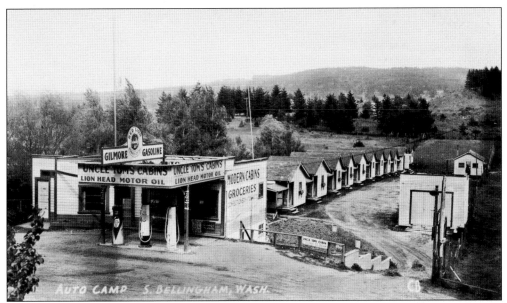

Uncle Tom's Cabins was adjacent to Fairhaven Park on the original Pacific Highway alignment at the southern limits of Bellingham. The 12 "modern cabins," Gilmore service station, and small grocery were operated by Thomas Bird and his wife, Joyce. Uncle Tom's was one of the first private auto camps in the Bellingham area, opening in about 1927; it had closed by 1936. (WM, 1999.0037.000011.)

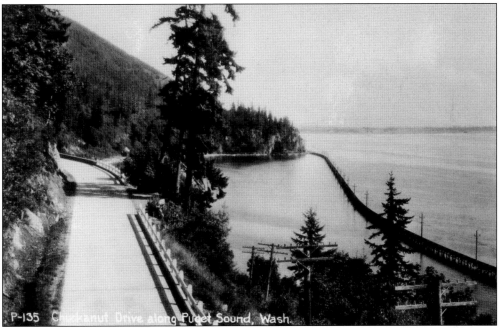

Early Pacific Highway travel from Bellingham to Burlington was via Chuckanut Drive. Contouring the shoreline of Chuckanut Bay, the 21-mile-long route cuts the face of Chuckanut Mountain as it weaves through evergreen forests. This segment of the Pacific Highway was bypassed in 1931, although for some years it continued to be designated as US 99-Alt. It remains a beautiful drive today.

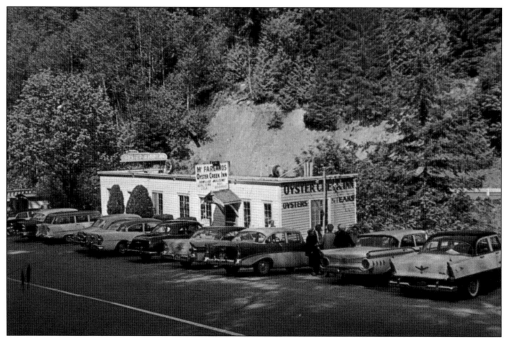

McFarland's Oyster Creek Inn is nestled in the deep ravine of Oyster Creek, about 11 miles south of Bellingham on Chuckanut Drive. The old highway curves sharply at this point, and the restaurant takes advantage of its setting overlooking the creek. The Oyster Inn dates to the 1930s and over time has expanded from a small roadside stand to become a popular, upscale dining spot.

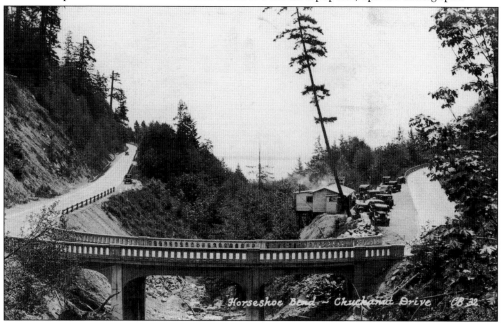

Horseshoe Bend on Chuckanut Drive was a hairpin turn over Oyster Creek. The creek cuts a narrow gorge into the face of Chuckanut Mountain, forcing the highway to dip down into the declivity to cross over the curved bridge seen here. An early version of the Oyster Creek Inn dangles over the edge of the stream; period automobiles crowd the roadside in front. (JCO'D.)

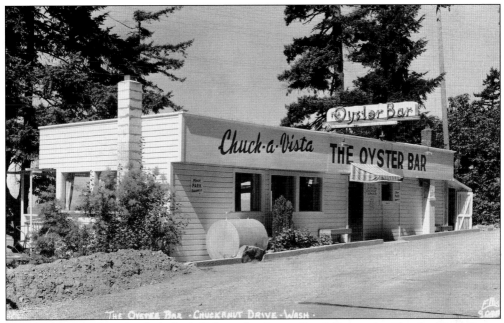

Just down the highway and up the hill from the Oyster Creek Inn is the Chuck-a-Vista Oyster Bar, perched on the edge of a 150-foot cliff overlooking Samish Bay. The Pacific Highway was so narrow at this point that there was barely enough room to park automobiles. Today, known simply as the Oyster Bar, the restaurant continues to attract diners from as far away as Vancouver, British Columbia. (WM, 2001.0012.000013.)

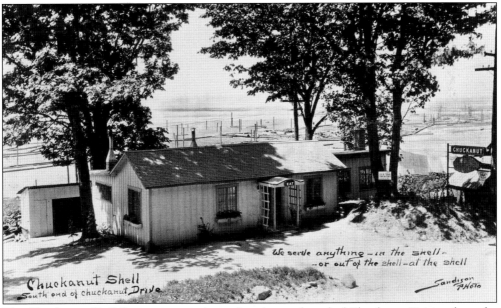

The Chuckanut Shell Restaurant was located at the south end of Chuckanut Drive, where the highway left its hill-clinging route to drop into the flat Skagit Valley. "The Shell" was owned and operated by Adelaide Knauf at this spot for several years, until she was forced to move her restaurant a few miles north to a new location overlooking Chuckanut Bay. That restaurant burned down in 1948. (WM, 2001.0011.000012.)

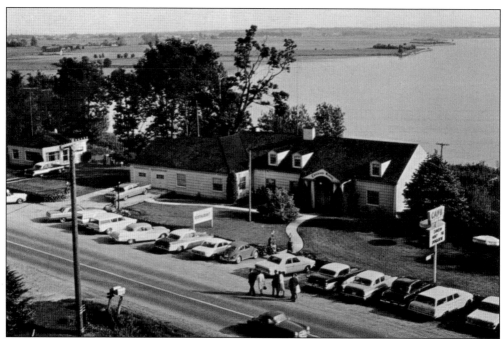

In 1934, the Tabor family of Bellingham purchased the site of the original Chuckanut Shell and built an elegant home that would later become the Chuckanut Manor Seafood & Grill. The property was bought by John and Carolyn Paulson in 1963, and the restaurant was expanded to its present size in 1968. Longtime owner Pat Woolcock continues the Manor's 45-year tradition of dining excellence.

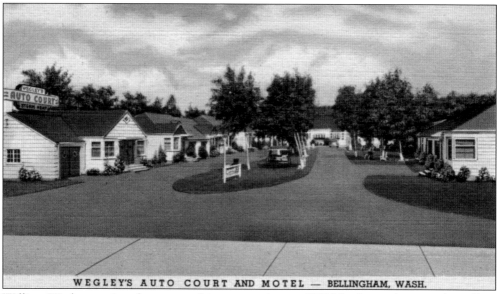

WEGLEY'S AUTO COURT AND MOTEL — BELLINGHAM, WASH.

William Wegley continued to operate his tourist cabins at 3302 Northwest Avenue after selling the Hamburger Express. By 1940, the cabins had been sold and renamed the Tedford Auto Court, and Wegley had opened this new motel at 208 Samish Highway on realigned Highway 99. Wegley's Auto Court promised quiet and beautiful surroundings and offered electric ranges, refrigeration, closed garages, and a playground for children.

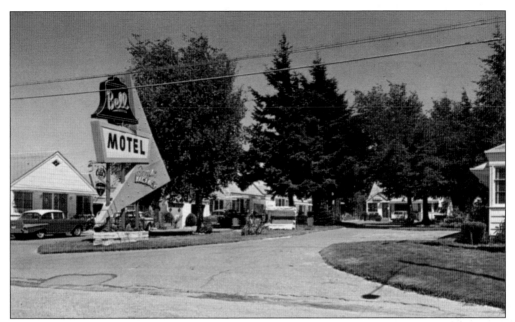

By 1950, Wegley's Auto Court had been sold to Mr. and Mrs. F.S. Baird and renamed the Bell Motel. In this c. 1957 view, the only apparent changes are the taller trees and a neon sign proclaiming the motel's name placed by the highway; otherwise, the U-shaped layout of 19 units is intact as built. A motel still operates at the site, but it has no resemblance to the original.

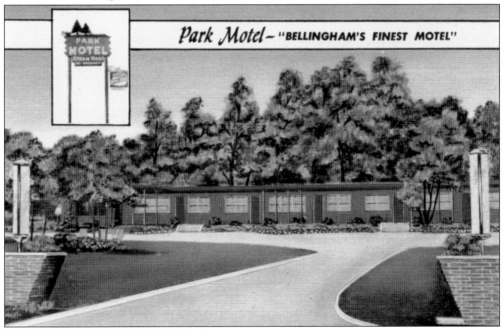

In the 1930s, Chuckanut Drive was bypassed by a direct route from Bellingham to Burlington. Samish Way became a main thoroughfare, and roadside businesses appeared along the new highway. The Park Motel, close to the city at 101 Samish Highway, epitomized 1950s styling with six modern units, each equipped with kitchens, refrigerators, hot water heat, and wall-to-wall carpets. The motel was managed by Mr. & Mrs. S.A. Eberhardt.

The 99 Motel was south of the Skagit River on Highway 99's approach into Mount Vernon. The motel dates to the early 1950s, and it appears as if the managers, Mr. and Mrs. I.S. Johnson, simply added onto their house to create tourist accommodations: quiet rooms with phones, TV, and closed garages, with an excellent restaurant and lounge adjoining. A Days Inn now occupies the site. (JCO'D.)

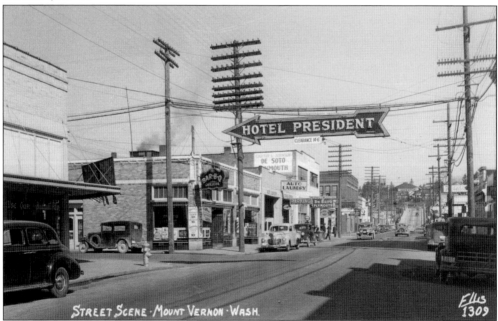

Highway 99 proceeded into downtown Mount Vernon on a viaduct over railroad tracks, as this view looking north shows. Businesses catering to motorists, including a De Soto-Plymouth dealership, a parking garage, and an "auto laundry" lined the west side of S 2nd Street. The Hotel President, a block off the highway on S 3rd Street, offered 125 rooms; rates started at $1.25 for those without a bath and at $2 for those with. (JCO'D.)

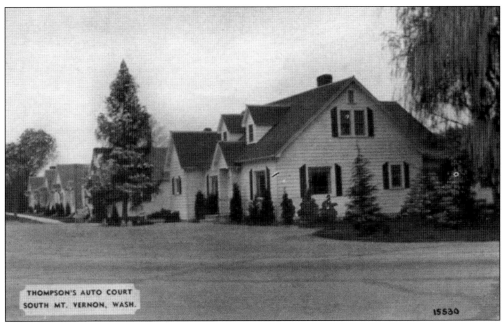

THOMPSON'S AUTO COURT
SOUTH MT. VERNON, WASH.

15530

At Mount Vernon's southern city limits was Thompson's Auto Court, with 17 "modern, [deluxe], moderately priced" cabins ranging in price from 50¢ to $3 per night. Each cabin had cooking facilities, steam heat, and innerspring mattresses. Bed linens were available for guests who did not bring their own. A service station and grocery store were adjacent. Mr. and Mrs. H. Thompson owned the motel at 1701 S 3rd Street. (JCO'D.)

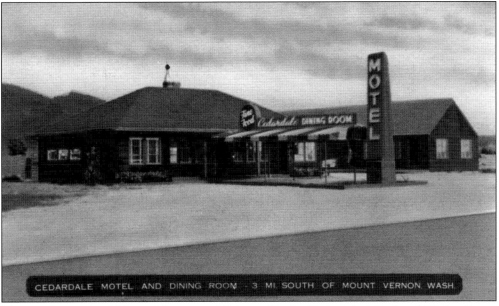

CEDARDALE MOTEL AND DINING ROOM 3 MI. SOUTH OF MOUNT VERNON, WASH.

Three miles south of Mount Vernon on Highway 99, the Cedardale Motel and Dining Room specialized in full-course dinners with homemade bread and pastries. Accommodations for one to six persons could be had in the motel units next door. After the Cedardale discontinued meal service, the motel remained in business for several additional years. The dining room still stands along the old highway.

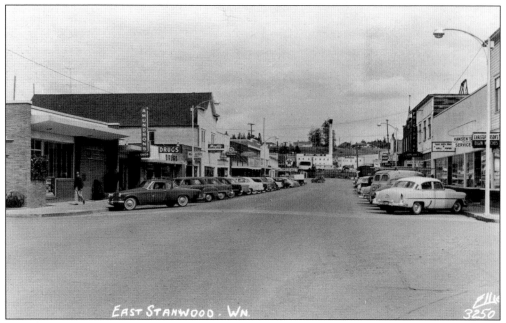

An early alignment of the Pacific Highway passed through the twin cities of Stanwood and East Stanwood on its way south to Marysville. By the 1930s, the highway had bypassed East Stanwood by half a mile, though the business district was still convenient for travelers. In the 1950s, a more direct route between Mount Vernon and Marysville was constructed, leaving the Stanwoods six miles off the main highway. (JCO'D.)

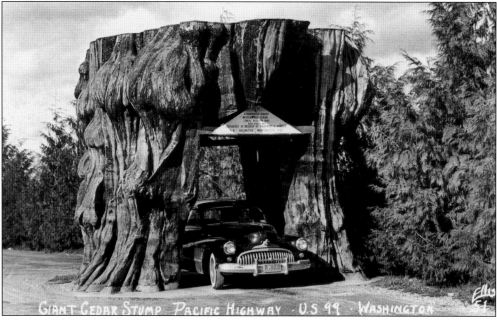

Who would not want to drive their car through a tree? The Giant Cedar Stump, originally on a pre-pavement segment of the Pacific Highway outside Arlington, gave early motorists the opportunity to try. "The Stump" moved around a bit before finally locating at the rest area off Interstate 5 a few miles north of Marysville, where a signboard tells its story.

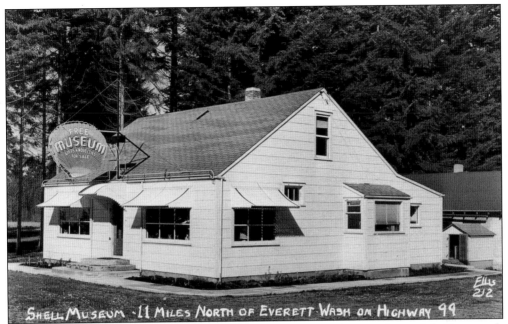

SHELL MUSEUM ·11 MILES NORTH OF EVERETT WASH ON HIGHWAY 99

This little museum was a typical roadside business, aiming to attract tourists and their money. It was the creation of Victor E. Anderson and was located along the highway north of Marysville. The museum sold shells from all over the world, as well as myrtlewood and redwood novelties, jewelry, and gifts. When Anderson died in 1953, his daughter continued to operate the museum; it has since disappeared. (JCO'D.)

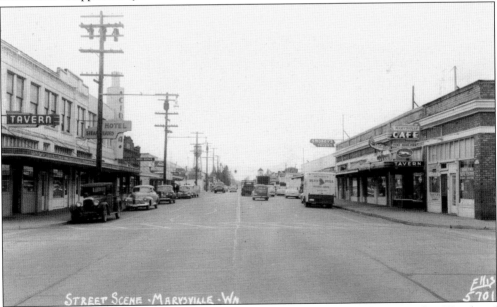

STREET SCENE ·MARYSVILLE ·WA

Marysville was the northern gateway to the most populous section of the state; after 75 miles of open country with a few cities and towns interspersed, the 1940s traveler entered 100 miles of nearly continuous development all the way south to Olympia. Though a small town, Marysville made the most of its location: over 60 roadside businesses called it home, such as the Marysville Café (at right in the photograph) at 202 State Avenue. (JCO'D.)

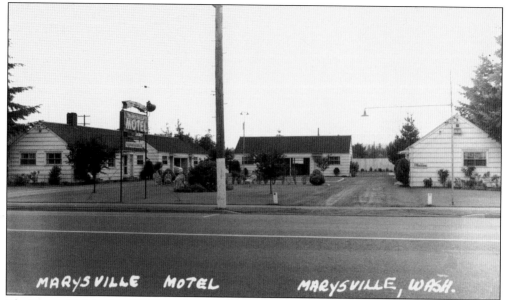

The Marysville Motel, at 903 State Avenue, was a U-shaped set of five duplex units arranged around an open courtyard. All units had television; some had kitchens and garages. A blinking neon arrow directed travelers to the motel. Several visitors can be seen enjoying the view of the highway from the grassy courtyard. The units are still in use as long-term rental apartments. (JCO'D.)

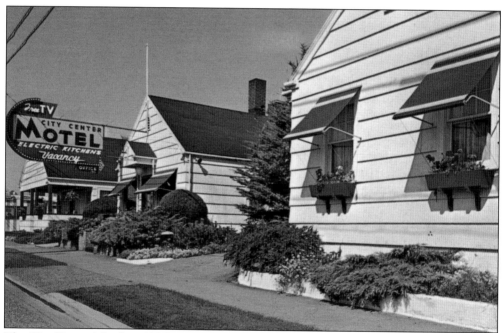

The City Center Motel, at 810 State Avenue, has operated under various names. In 1941, it was March's Motel; in 1948, the Wicksham; by 1959, it was called the Du-Kum-In Motel. Mr. and Mrs. Larry Loretz renamed it the City Center, by which name it is known today. Along with the usual amenities—TV, tubs and showers, and kitchen units—the City Center offered "live, piped-in organ music." (JCO'D.)

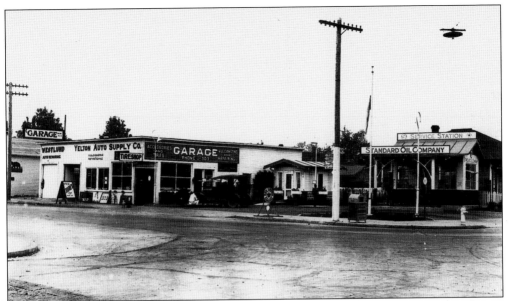

An early gas station sits at the corner of State Avenue and 3rd Street in Marysville. Next door at Yelton's garage, someone—perhaps the owner—is replacing the tire on an automobile. Although the station carries the banner of Standard Oil, the sign out on the sidewalk advertises Red Crown gasoline. (JCO'D.)

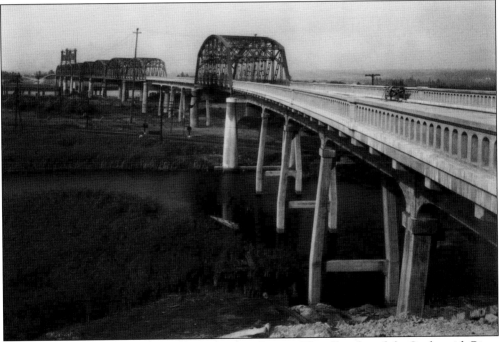

The August 1927 opening of the new "cut-off" bridge over Ebey Slough and the Snohomish River between Marysville and Everett was cause for celebration. The route shortened the distance by five miles, and the earlier river road route—a long, often muddy stretch of difficult turns—was eliminated. The bridge was one of the last links in an end-to-end, all-concrete Pacific Highway in Washington. (MOHAI, 1983.10.3786.6.)

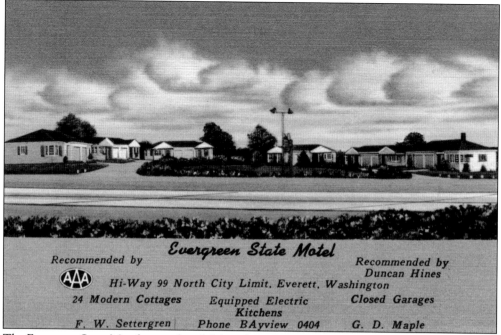

Evergreen State Motel

Recommended by AAA

Recommended by Duncan Hines

Hi-Way 99 North City Limit, Everett, Washington

24 Modern Cottages Equipped Electric Kitchens Closed Garages

F. W. Settergren Phone BAyview 0404 G. D. Maple

The Evergreen State Motel opened with 24 modern cottages set around an open green space. All were completely equipped with kitchens, electric ranges, and closed garages. Operated by F.W. Settergren and G.D. Maple, the motel emphasized outdoor recreational opportunities, with golfing and saltwater and freshwater fishing nearby. The Evergreen State received recommendations from Duncan Hines and AAA.

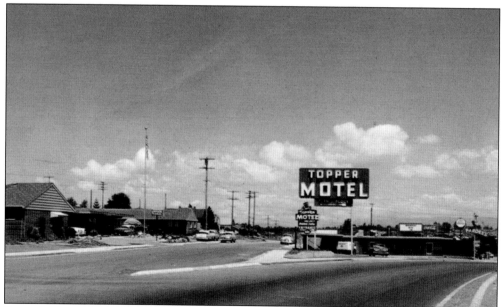

Everett's Topper Motel and its top-hat sign were at 1030 Broadway in Everett where the highway dropped down toward the Snohomish River. Owners Mr. and Mrs. James M. Cavelero offered Simmons beds, Beautyrest mattresses, carpeting, tile baths, and tubs and showers in all rooms; some units also had kitchenettes and phones. Pardee's restaurant was adjacent to the motel.

Two

Everett to Seattle

After completion of the Snohomish River bridges, Highway 99 entered Everett on Broadway; the earlier circuitous route up the river had come into the city on Everett Avenue. Downtown, the highway turned west on either Everett or Pacific Avenues (the route varied over time), then followed Rucker Avenue south.

Near 52nd Street SE, Rucker Avenue became the Bothell-Everett Highway, skirting Silver Lake on its way to Bothell about 15 miles distant. At Bothell, the highway turned west on Bothell Way, following it to Roosevelt Way and then Eastlake Avenue into downtown Seattle. This was the official route of the Pacific Highway until at least the late 1920s; for a short time, it carried the Highway 99 label.

The Seattle-Everett Highway, more direct and slightly shorter, soon became the main arterial. Opened in late 1927, by the early 1930s it had been formally designated Highway 99. The new highway departed from the old at 42nd Street SE and Rucker Avenue in Everett. The Bothell-Everett Highway, while remaining busy, was no longer the main route to Seattle.

Businesses were quick to build along the new highway. In 1939, Highway 99 south of Everett was described as "running between fruit and vegetable stands, scattered houses, and suburban beer parlors, roadhouses and skating rinks catering to those seeking out-of-town amusements." Roadhouses were among the first businesses to appear along the new highway. Located in remote areas at the fringes of the law's jurisdiction, these restaurant-nightclubs attracted swarms of revelers. Some of the roadhouses strove for legitimacy; many acquired seedy reputations as speakeasies and gambling dens. Intercity growth eventually drove them from business.

Local names competed with the official Highway 99 label. Common usage continued to refer to the entire route as the Seattle-Everett Highway. South of the divergence of the old and new highways in Everett, the highway was also called Evergreen Way for about five miles, at which point its name became Pacific Highway. The Snohomish-King County line marked the start of heavily developed Aurora Avenue, which name it retained until terminating at Denny Way in downtown Seattle.

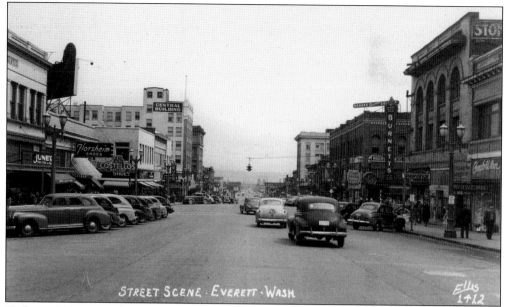

Highway 99 traverses busy downtown Everett in this view. Signs advertising Florsheim Shoes, Costello's Men's Wear, Pay Less Drugs, Burnett's Jewelery, Meves' Restaurant, and several fountain lunches hang above the crowded sidewalks. Everett's streets were built exceptionally wide to accommodate several lanes of traffic and diagonal parking. An early stoplight—apparently only two colors—dangles above the intersection. (JCO'D.)

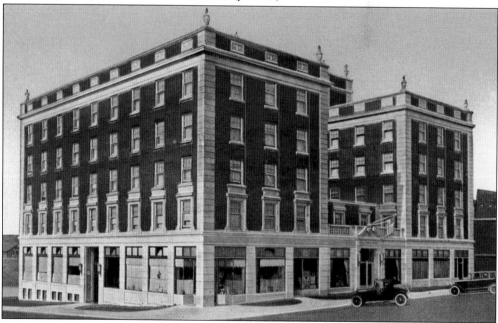

At 1507 Wall Street, the Hotel Monte Cristo, built in 1925, was a center of civic life in Everett. It began advertising to the motoring public as early as 1930, offering 150 "new and fine" rooms at rates starting at $1.50 for those without a bath and $2 for those with; a coffee shop operated in the hotel. As the glory days of elegant hotels passed, the Monte Cristo fell into disrepair; it is now restored as affordable housing.

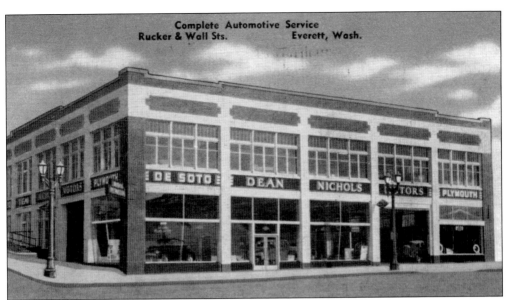

Service stations along the highway south of Vancouver provided basic automotive services—gas, oil, and tire repair—but in the event of a major problem, a motorist would need to reach a large city for assistance. They could find anything from a gas fill-up to a new car in Everett at Dean Nichols Motors, located at a corner where the Pacific Highway turned south after jogging through downtown. (JCO'D.)

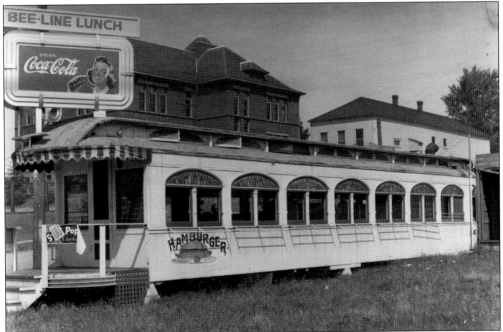

This interurban car-turned-diner, the Bee-Line Lunch, sat at 3201 Rucker Avenue. In this photograph, the windows along the roofline have been opened for ventilation, and business appears slow. The car still has leaded glass panels above the arched windows. An enticing painting of a hamburger decorates the side panel; a Popsicle ad hangs from the railing; and, on the billboard, a smiling girl enjoys her Coca-Cola. (WVS.)

This totem pole was originally in downtown Everett; it was moved to this location at 44th Street SE in the 1940s. In this view looking north, Evergreen Way is arcing in from the left and Rucker Avenue is heading north past a Sav-Mor Time gas station. Angling in on the right is the Bothell-Everett Highway, the earlier main route between Everett and Seattle via Bothell.

The Bothell-Everett Highway curled around the northeast corner of Silver Lake about six miles south of downtown Everett. This section of the Pacific Highway followed an earlier road into the area around the lake, still lightly populated in the 1910s. When the highway was paved with concrete in 1916, it gave day-trippers easy access to Silver Lake, which soon became a popular spot for picnicking and swimming. (JCO'D.)

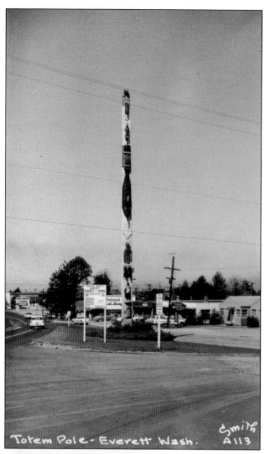

Totem Pole - Everett Wash.

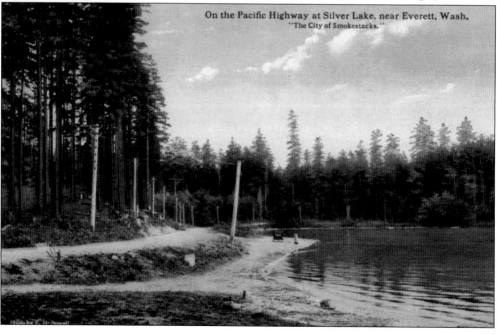

On the Pacific Highway at Silver Lake, near Everett, Wash.
"The City of Smokestacks."

By the 1920s, Silver Lake was more developed. Homes bordered the lake, and roadside businesses were springing up to serve travelers on the increasingly busy Bothell-Everett Highway. On the right in this view is Stallings Bros. Service, a one-pump gas station/tire repair shop. Though the Pacific Highway designation shifted over to the Seattle-Everett Highway soon after the latter was completed in 1926, this route is a crowded four lanes today. (JCO'D.)

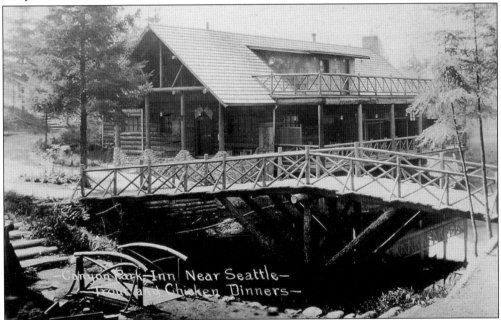

In 1925, a resort called Canyon Park Inn opened just off the Pacific Highway two miles north of Bothell. The park included an auto camp, picnic grounds, dance pavilion, and fish hatchery; the Canyon Park Inn served chicken dinners. Scenic spots, including Mount Rainier and Snoqualmie Falls, were reproduced in miniature among the trees. The hatchery outlasted the other attractions, operating into the 1960s; it, too, is now gone. (RKE.)

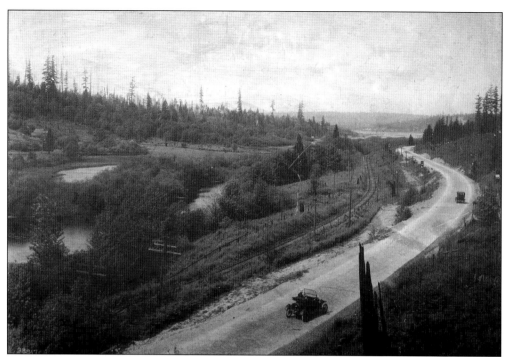

Two early automobiles trundle their way westward in this early view of brick-paved Bothell Way about a mile southwest of Bothell. The Sammamish River is to the left; Lake Washington can be seen off in the distance. At that time, the countryside was undeveloped; if the same motorists were to retrace their route today, they would be astonished by the growth that has occurred. (RKE.)

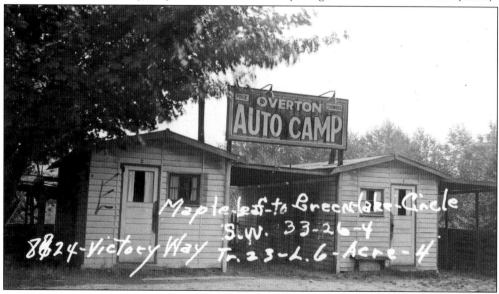

Sanford Overton's camp, located at 88th and Bothell Way on the early alignment of the Pacific Highway, first appeared in the Seattle directory in 1929. An example of early auto camp architecture, Overton offered 10 cabins, each with an unfinished interior, one electrical outlet, a sink but no toilet, and a covered garage, at rates between $1 and $1.25 a night. Overton's later became the North End Auto Camp and was eventually demolished in 1968. (WSA-PSR, 510140-1980.)

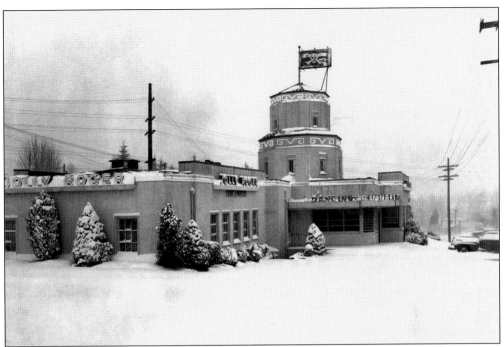

This Art Deco–style, pink stucco building at 8721 Bothell Way was the Chinese Castle from 1933 until 1935, when it was remodeled and reopened as the Jolly Roger. A popular dance hall and restaurant, the Jolly Roger had difficulty shedding the sordid reputation of its predecessor. The building, with skull and crossbones flying from the tower, was declared a Seattle Historic Landmark in 1979; it fell victim to an arsonist in 1989. (RKE.)

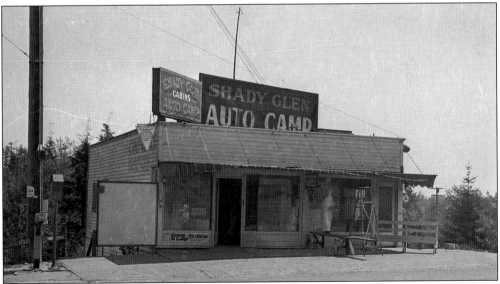

Shady Glen was one of the earliest and longest-lasting auto camps in the Seattle area. First listed in directories in 1927, it was still in business in 1954. The camp (later auto court) offered 44 cabins ranging in size from one to three rooms, with prices starting at $1 per night. There was a grocery store and a laundry facility on the premises, and tourists could take a streetcar into the city. (WSA-PSR, 510140-0387.)

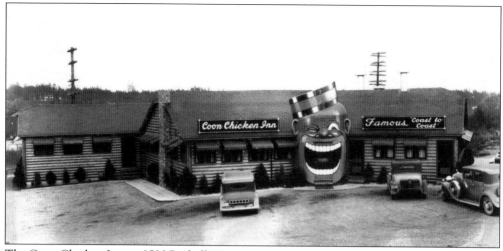

The Coon Chicken Inn, at 8500 Bothell Way, was one of a chain of three created by M.L. Graham (the others being in Salt Lake City and Portland). This c. 1930 view shows the destination shortly after its opening. The menu featured chicken—dinners, pies, noodles, and sandwiches, all from "milk-fed chickens"—as well as steaks and hamburgers. The Coon Chicken Inn closed in the 1950s. (TJC.)

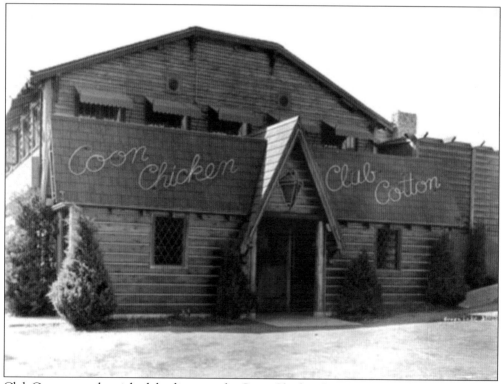

Club Cotton was the nightclub adjunct to the Coon Chicken Inn, opening with great fanfare in February 1934, in a lower level of the building. As many as 250 people could be accommodated by the club. Dining, dancing, and entertainment by the Club Cotton Merrymakers were offered on a nightly basis with no cover charge. Club Cotton closed with the Coon Chicken Inn; both have disappeared. (TJC.)

36

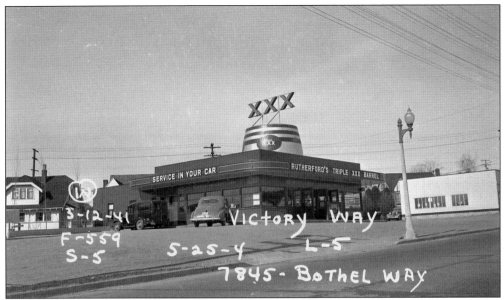

In October 1940, Harry Rutherford opened a Triple XXX Barrel at 7845 Bothell Way, which, though no longer Highway 99, was still a major route between Seattle and points north. Rutherford built his first Triple XXX in Renton in 1930. In 1940, he expanded his root beer empire by adding three more in rapid succession, all featuring the distinctive giant barrel. This one still stands, now serving as a Chinese restaurant. (WSA-PSR, 890450-0025.)

Construction of the Seattle-Everett Highway, utilizing portions of the older North Trunk Road, had commenced by late 1925. It was completely paved by November 1927. The Everett-Bothell Highway continued to carry the Highway 99 designation for a few more years, but traffic and development soon shifted over to the new alignment, which was four miles shorter than the old route via Kenmore and Lake City. (MOHAI, 1983.10.3817.7.)

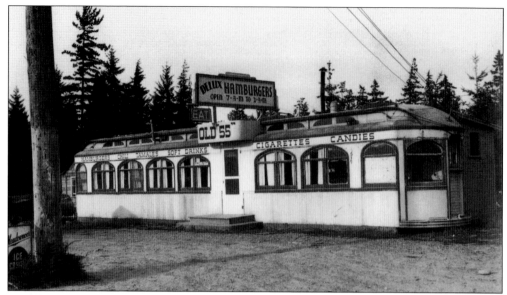

In 1939, Everett natives Vern Williams and Maxine Mark purchased interurban car no. 55, moved it to 7309 Highway 99 S, and opened the Old "55" Café. The menu featured hamburgers, chili, tamales, and other light lunches. Its career as a diner over, the "55" was left to deteriorate by the highway until 1964, when it was donated to the Northwest Railway Museum. The City of Lynnwood later bought and fully restored it. (WVS.)

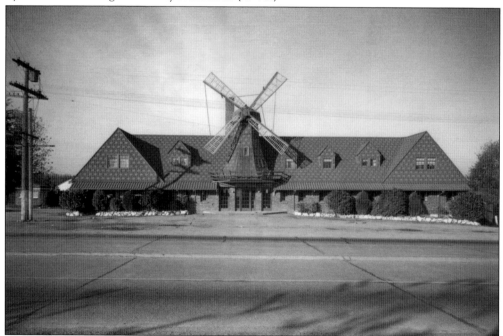

The new Seattle-Everett Highway opened in 1926 and was soon lined with dine-and-dance roadhouses on the undeveloped stretch between the cities. The Windmill was one such place, located about two miles south of Everett at 7426 Highway 99 South. Over the years, the Windmill acquired a shady reputation (as did many roadhouses that had initially offered legitimate entertainment). The building survived into the late 1950s. (MOHAI, 1983.10.16128.1.)

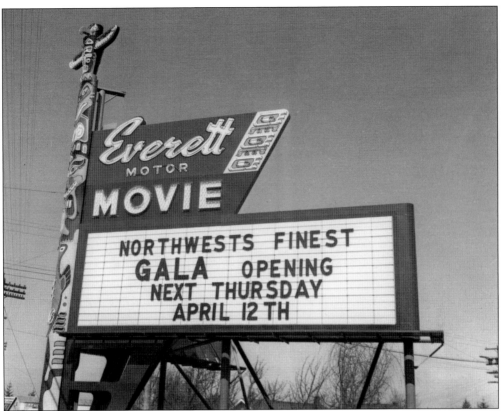

In most cities, this would have been called a drive-in theater; in Everett, it was the "Motor Movie." The swoop-wing sign, resplendent with a totem pole, announces the theater's grand opening in April 1951. Movies were shown on a 60-foot-wide screen; concessions and restrooms were sited to allow full view from the 750 parking spaces. The Motor Movie has since been replaced by a shopping mall. (JCO'D.)

Much of the countryside through which the Seattle-Everett Highway was built was made up of small farms and logged-off land. The Puget Sound Mill Company, based in Port Gamble, took advantage of the new highway to market thousands of acres of its stumplands as potential homesites. Shown here around 1929 is the company's real estate office along the new highway at Lake Serene. A lakefront half-acre could be purchased for $1,000. (AMHA.)

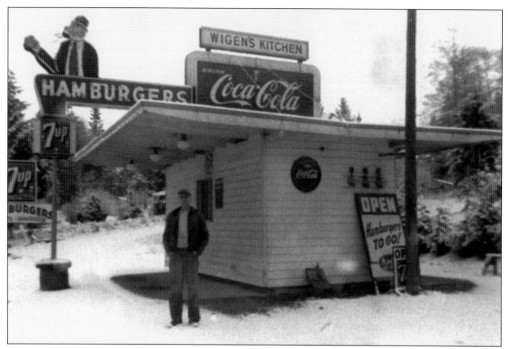

Owner Clarence Wigens is seen standing in front of his drive-in on Highway 99 in August 1956. Formally known as Wigen's Kitchen, its distinctive sign featuring a well-known character from the *Popeye* cartoon gave it its familiar name: "Wimpy's." The tiny restaurant offered take-out hamburgers, Coca Cola, and 7-Up. (AMHA.)

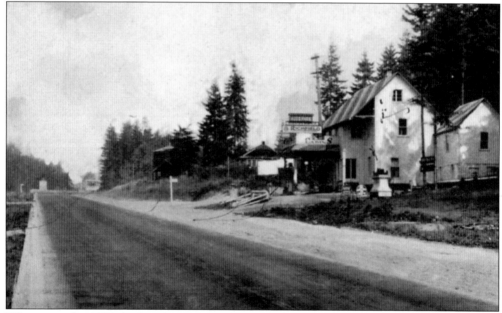

When opened in 1927, the Seattle-Everett Highway ran through miles of undeveloped country devoid of services. Keeler's Korner, a welcome sight for motorists located almost exactly midway between the two cities, was among the earliest businesses to spring up along the highway in what is now Lynnwood. This view looks north up a long hill to the flatlands that lead to Everett. (AMHA.)

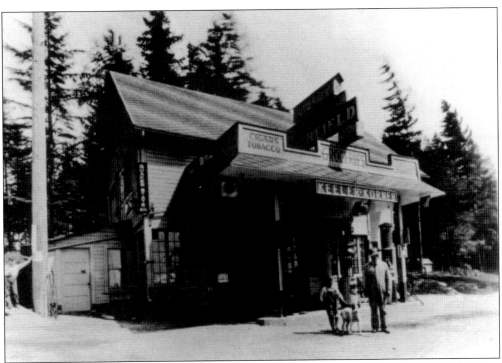

The Keeler family (pictured here in 1930 are dad Carl, son Frank, and their dog) ran the combination grocery store/gas station and lived in quarters above the store. Two glass-topped pumps dispensed Richfield gasoline at 15¢ a gallon. Tire and lube services were available, as well as cabins for overnighters. Long a highway landmark, Keeler's Korner is listed in the National Register of Historic Places. (AMHA.)

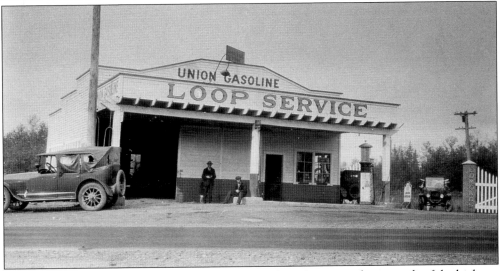

Loop Service was located a quarter mile south of Keeler's Korner, on the west side of the highway at its intersection with 168th Street Southwest. The station had a large service bay for repairs but only a single gas pump The highway divided Edmonds and Lynnwood; a telephone call from the Loop, in Edmonds, to Keeler's Korner, just up the highway but in Lynnwood, was a long-distance call. (AMHA.)

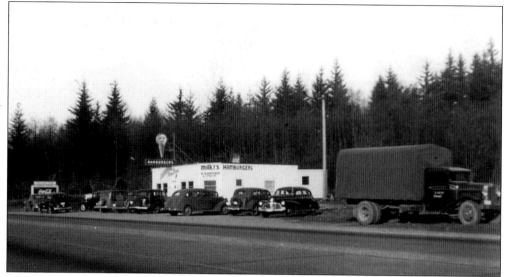

Classic automobiles surround the Pine Cone Cafe, located on Highway 99 just north of 176th Street Southwest. Built in the 1940s, the café was owned by Marvin Gunderson on family land that had been split by the new highway. The pinecone-shaped sign advertised hamburgers; the restaurant provided both fountain and booth service. (AMHA.)

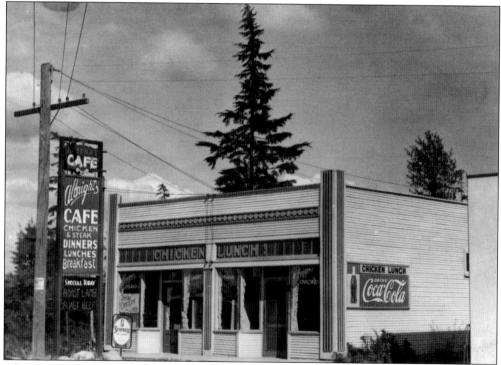

Albright's Cafe represents a step away from the simple, shack-like eateries that lined the early highway. With its solid-looking construction, dual entry doors, and corner columns, the building radiates an air of permanence. Albright's was located at the Alderwood Crossroad (now 196th Street Southwest). Chicken lunches and dinners were standard fare; the day this photograph was taken, roast lamb and beef were the daily specials. (AMHA.)

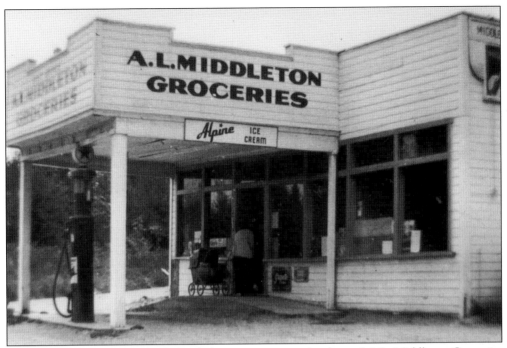

An unidentified woman wheels her baby carriage up to the door of A.L. Middleton Groceries in this undated photograph. Middleton's establishment was typical of early roadside businesses that catered to the traveler by providing in one place everything they might need—in this case, groceries, gas, and ice cream. Middleton's was located on the Pacific Highway at 212th Street in the Seattle Heights district. (AMHA.)

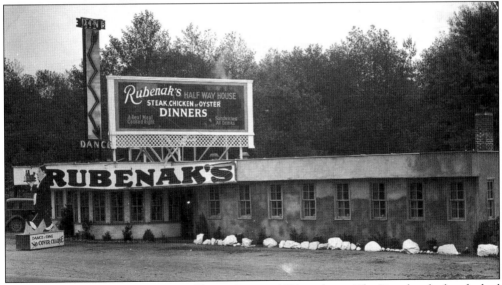

Frank Rubenak opened Rubenak's Half Way House in 1933, replacing The Pig, a lunch place he had previously operated at the site. Rubenak's offered dining (steak and chicken dinners) and dancing to live music. Located on the east side of Highway 99 near 188th Street Southwest, Rubenak's remained popular during the 1930s and 1940s but faded with other Highway 99 roadhouses as tastes and times changed. (AMHA.)

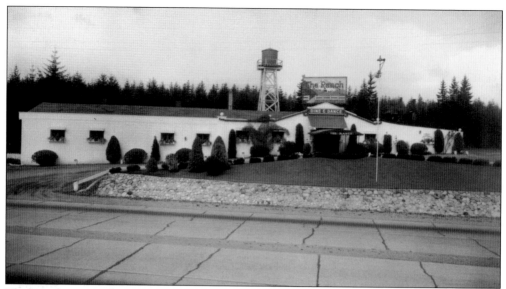

The Ranch was another notorious roadhouse on the Seattle-Everett Highway. Located eight miles north of Seattle's city limits, the Ranch was frequently mentioned in newspaper reports of gambling and liquor raids. By 1940, it apparently had cleaned up its act and was billing itself as a "dining and dancing resort," offering "tempting dinners" prepared by chef Otto and musical entertainment courtesy of "Boob" Whitson, "the Gentleman of Song." (MOHAI, 1983.10.4584.1.)

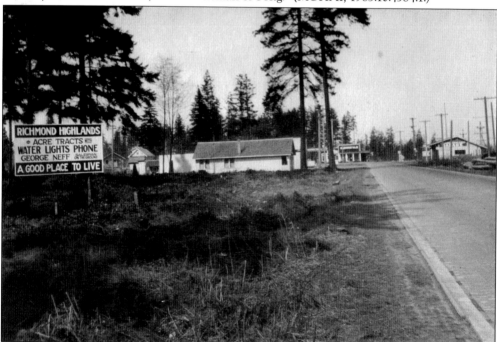

This 1922 image shows the original brick highway that preceded the Pacific Highway in Shoreline. The view looks north from the vicinity of what is now N 183rd Street. The Rogers General Store, the first business in what was then called Richmond Highlands, is straight ahead on the highway; Roy Haines's garage and the line of the Seattle-Everett Interurban Railway are on the right. (SHM, 136.)

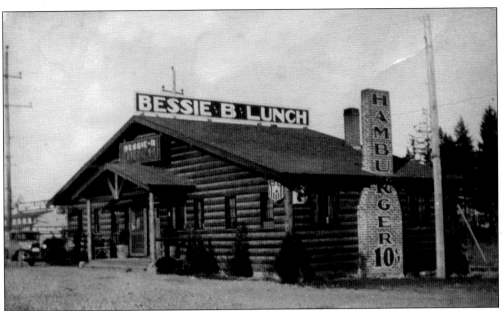

In 1921, Bessie Haines opened a lunch counter in husband Roy's garage to serve passengers at the interurban station. By 1933, she had moved into this log restaurant on Aurora Avenue at N 185th Street. Bessie's was a familiar landmark—not only to highway travelers, but also to locals who met for "coffee hour." Bessie retired in 1959; the café lasted for a few years but is now gone. (SHM, 65.)

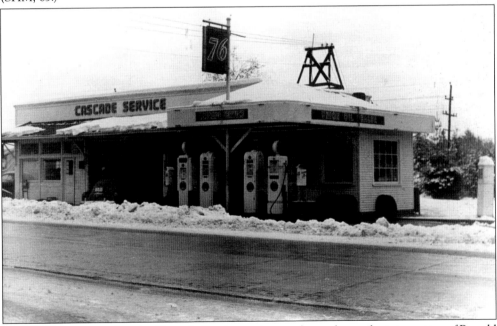

Seen here on a snowy day, the Cascade Service station was located near the intersection of Ronald Place N and Aurora Avenue, adjacent to the Ronald interurban station. A cluster of businesses had sprung up around the station but migrated slightly north and east when the Seattle-Tacoma Highway came through in the 1920s. A segment of the original brick highway can be found at this spot. (SHM, 353.)

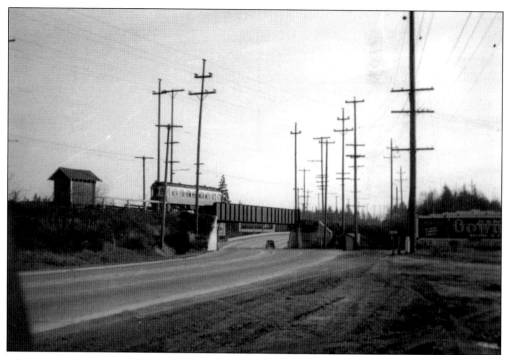

New transportation meets old: an auto zips under the Pershing Bridge on the Seattle-Tacoma Highway while a car of the Seattle-Everett Interurban Railway passes overhead. The railway ran for 29 years with over 20 stations—most of them only small, shack-like structures—along the route. This view shows the overpass at Aurora Avenue and N 155th Street in Shoreline. (SHM, 124.)

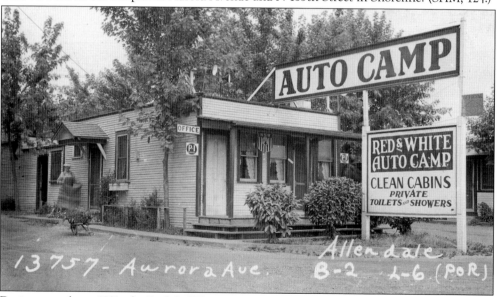

Dating to at least 1931, the Red & White Auto Camp offered 31 private cabins arranged in two parallel rows stretching back from the highway. Each unit was equipped with a toilet and shower. A small grocery store and café were located on the premises, and Roy's Service Station was right next-door. Located at 13757 Aurora Avenue, it was renamed the Paradise Motel by the 1940s. (WSA-PSR, 016400-0115.)

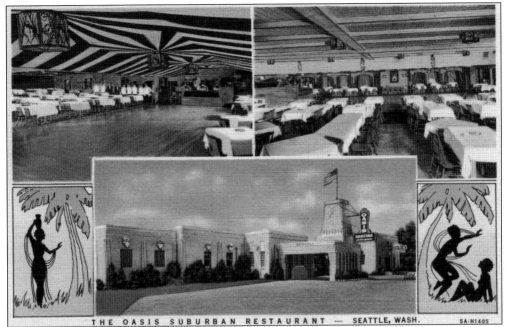

THE OASIS SUBURBAN RESTAURANT — SEATTLE, WASH. 5A-H1405

The Oasis established itself as a typical roadside eatery soon after construction of the new Seattle-Everett Highway; in 1931, a dance hall was added. Originally a pair of frame buildings, the Oasis was completely remodeled in an Art Deco–Streamline style in 1938 and billed itself as "the largest and finest Suburban Restaurant in the Pacific Northwest." It offered dining, dancing, and continuous entertainment nightly.

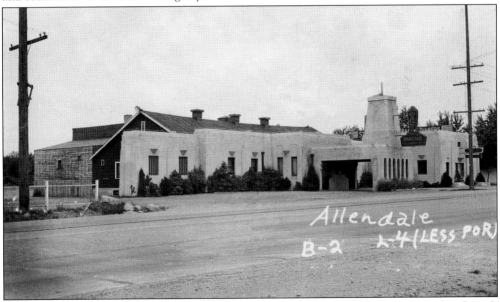

This photograph shows the Oasis's efforts to upgrade its image: a long, narrow stucco facade with towers and pediments was added to the street side of the original building to create an exotic entrance. The grand reopening in February 1938 solidified the Oasis's reputation by featuring Bernie Stephens's orchestra, blues singer Imogene Hewitt, and other entertainment. The building was destroyed by a fire in March 1947. (WSA-PSR, 016400-0080.)

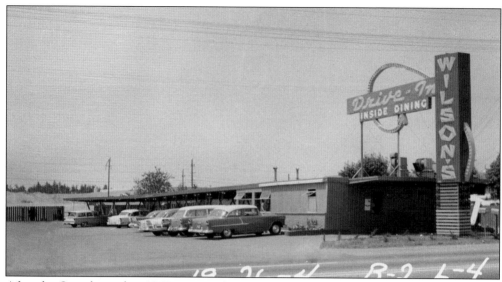

After the Oasis burned in 1947, owner John Wilson took advantage of the drive-in restaurant craze and built a more modest business on the same spot. With a drive-up window and covered parking for up to two-dozen cars, Wilson's was a popular hangout for more than a decade, as this 1958 view shows. The site is now occupied by industrial buildings. (WSA-PSR, 016400-0080.)

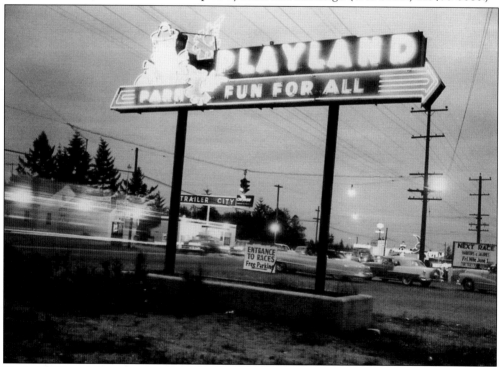

Playland, "Seattle's amusement park," was located just off Highway 99 and N 130th Street on Bitter Lake. The park opened in 1930 and offered a wide range of amusements, such as the Dipper, the Fun House, the Buzzer, the Giant Whirl, the Dodgem, the Playland Dance Band, a miniature railroad, and scores of others. The park suffered a series of fires and was torn down in 1961. (SHM, 2009-22-011.)

48

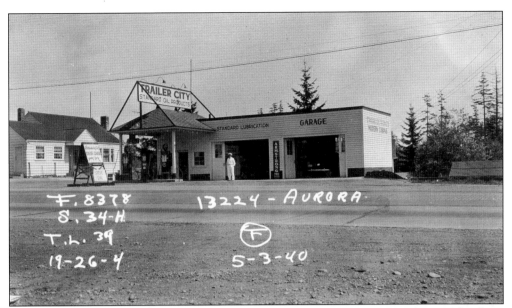

As the Seattle-Everett Highway neared completion in 1927, businesses sprung up in the then-undeveloped area through which the highway passed. Trailer City, at 13224 Aurora Avenue, was among the earliest, offering a two-bay service station, a small grocery store, trailer spaces, and (in later years) an auto court. Margaret Timm owned Trailer City when this photograph was taken in 1938; it had been demolished by 1969. (WSA-PSR, 192604-9371.)

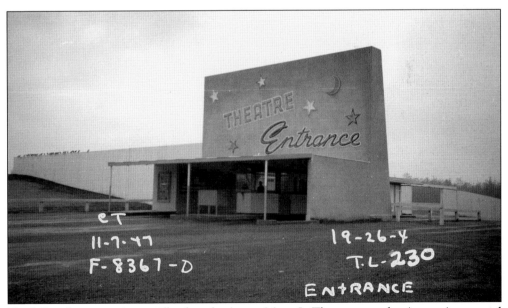

North Seattle was growing rapidly when the Aurora Motor-In Theatre opened at Aurora Avenue and 135th Street in July 1946. The venue, accommodating 650 vehicles and equipped with individual car speakers, was surrounded by a wall to prevent passers-by from seeing a free show. The opening attraction was *Birth of the Blues*, starring Bing Crosby. (WSA-PSR, 192604-9230).

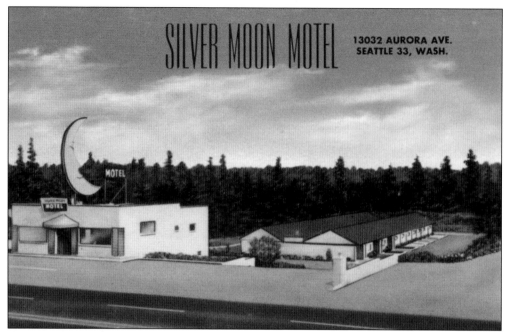

The Silver Moon Motel, at 13032 Aurora Avenue, opened around 1950. Inviting travelers to "sleep off the highway," the motel offered 18 soundproof units with individual electric heat, extra-long beds, and wide garages in a wooded setting. The motel's incomparable "man in the moon" sign dominated the office building out by the highway and could hardly be overlooked.

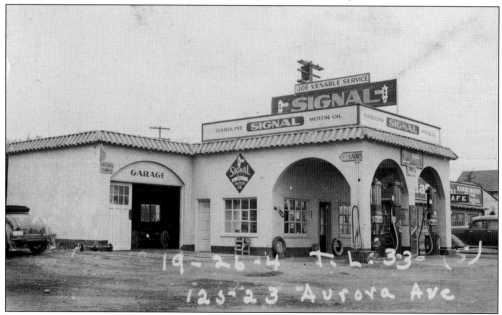

Joe Venable's Signal station occupied this site at 12523 Aurora Avenue from 1935 into the 1950s. Its Spanish Mission-style architecture, with arched porticos and tile roof, was a departure from the utilitarian design of gas stations up to that time. The station did it all—pumped gas, changed oil and tires, and charged batteries in the garage section at the building's rear. (WSA-PSR, 192604-9343.)

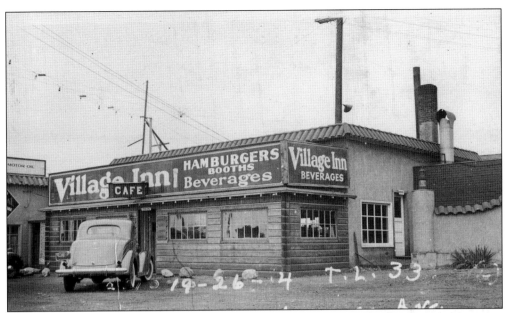

The Village Inn was Joe's next-door neighbor and shared the same style of architecture—except for the front portion of the building, which appears to have been constructed of squared logs as an add-on to the original tiled, stucco structure. Though built in the mid-1930s, the Village Inn did not appear in Seattle's business directory until 1951. (WSA-PSR, 192604-9343.)

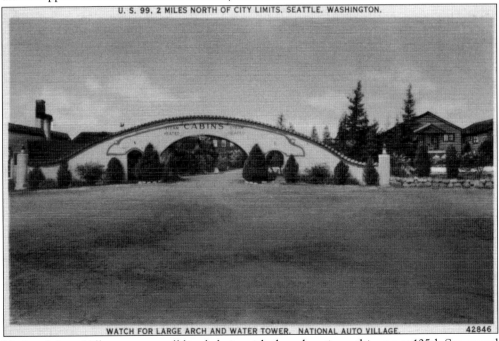

National Auto Village was a small local chain with three locations: this one at 125th Street and Highway 99, another a mile south at 85th Street, and a third at 10000 E Marginal Way south of Seattle. The 125th Street site, with its splendid arch, contained over 50 units in a variety of configurations—some fully furnished with private baths, others without toilets and providing only the necessities.

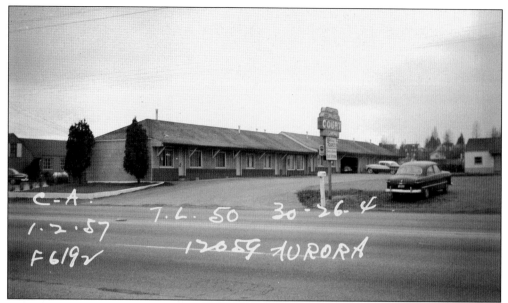

The intersection of Aurora Avenue and N 125th Street was the start of "Motel Row" for southbound travelers. Five motels lined the highway in the space of a few hundred yards. First up was the Seattle Auto Court at 12059 Aurora Avenue, built in 1942, a typical arrangement with office and sign out by the highway and rooms arranged in a single row perpendicular to the road. (WSA-PSR, 302604-9050.)

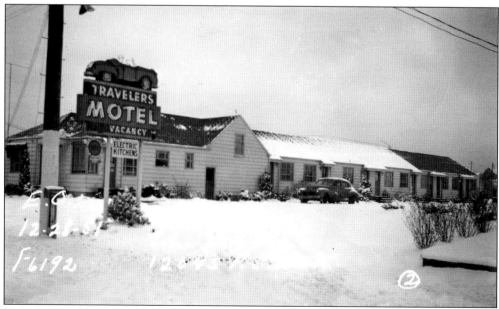

Next door to the Seattle Auto Court was the Travelers Motel at 12045 Aurora Avenue. Built in 1948, the Travelers offered 10 units with "electric kitchens" and bathrooms, though only four of the units had shower stalls. In this snowy scene, guests' cars are left to fend for themselves out in the weather. The motel's distinctive sign shows a driver perched in an automobile high atop the signpost. (WSA-PSR, 302604-9080.)

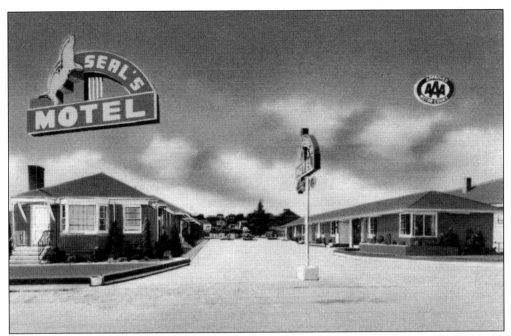

Seal's Motel, at 12035 Aurora Avenue, was built by Ernest H. Seal in 1946 and remodeled in 1952. It featured 17 units—a variety of one-, two-, and three-room configurations, all with radiant heat, Beautyrest mattresses, tiled baths, and free radio. Seal's was owned by Mr. and Mrs. C.R. Pierce in 1954. The seal-motif sign is gone, but the motel is still operating.

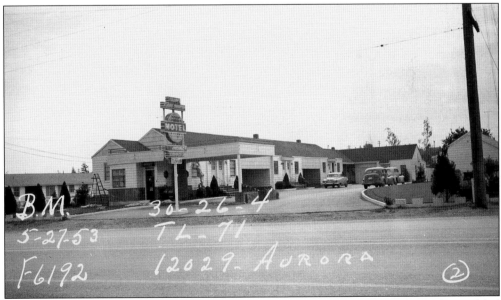

The Globe Trotter Motel, at 12029 Aurora, was built in 1942, added onto in 1944, and remodeled in 1952. By the time of this photograph, the Globe Trotter sported a porte cochere for arriving guests' cars. There were 12 units available, ranging from one to four rooms each, with a television in each unit. Enclosed garages and a cool, grassy recreational area completed the amenities. (WSA-PSR, 302604-9071.)

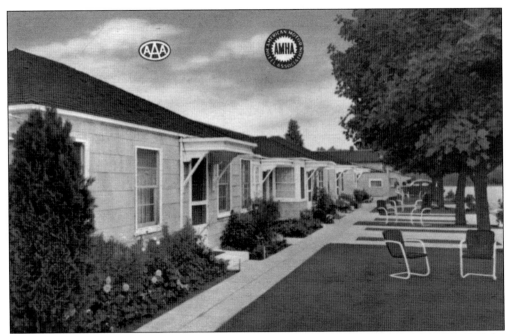

In 1937, George Hyatt was running the Vista Auto Court at 9541 Aurora Avenue; by 1939, he had relocated a half-mile north to 10901 and opened Hyatt's Aristocratic Auto Court. Each unit had hot water, wall-to-wall carpets, and tub and tiled showers; some had kitchens. Flower beds fronted each cabin, and a lawn with comfortable chairs under shade trees invited travelers to relax after a long day's drive.

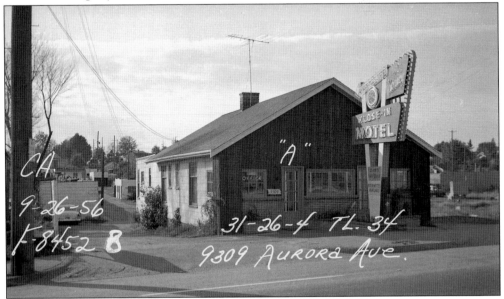

The Klose-In Motel was possibly the first motor court to be built in north Seattle. Dating to 1930, it consists of a long row of cottages interspersed with covered parking for automobiles. The office building served as a grocery store in early days; the neon sign, with a working clock, was a 1950s addition. Eighty years on, the Klose-In is still in business at 9309 Aurora Avenue. (WSA-PSR, 312604-9034.)

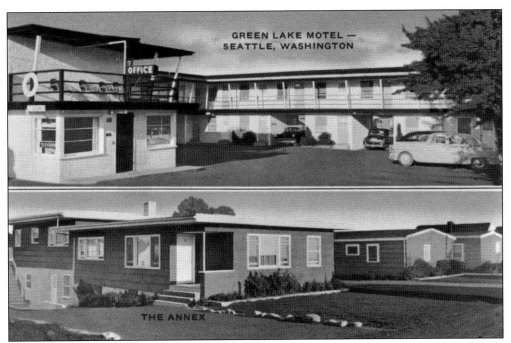

GREEN LAKE MOTEL —
SEATTLE, WASHINGTON

THE ANNEX

Unlike many motels fronting directly onto busy streets, the Green Lake Motel, at 8900 Aurora Avenue, sits 100 feet back from the highway. Built around 1947, the motel was one of the first in the Seattle area to adopt the new two-story design that was gaining popularity. There were 39 modern units offered, including large family units with electric kitchens. There was also a restaurant on the premises.

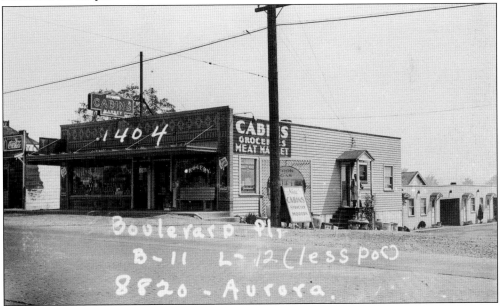

In 1932, it was called Best Auto Camp; in 1938, it was Weber's Auto Camp; by 1948, its name was Liberty Bell Auto Court. Located at 8820 Aurora Avenue, this spot evolved over time from a grocery store with a single row of "modern cabins" to a more typical U-shaped configuration consisting of 19 units (but no grocery). The Liberty Bell survived into the 1970s. (WSA-PSR, 099300-0645.)

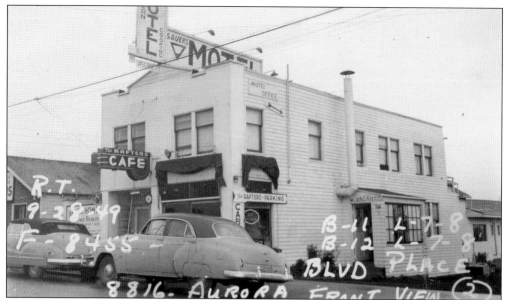

This building at 8816 Aurora Avenue housed both Sauers Motel and the Rafters Cafe in 1949. The motel consisted of a total of 23 units: one- and two-room apartments in the main building and a row of 10 cabins in the rear. By 1956, the café had disappeared and the motel had taken over the entire building. (WSA-PSR, 099300-0635.)

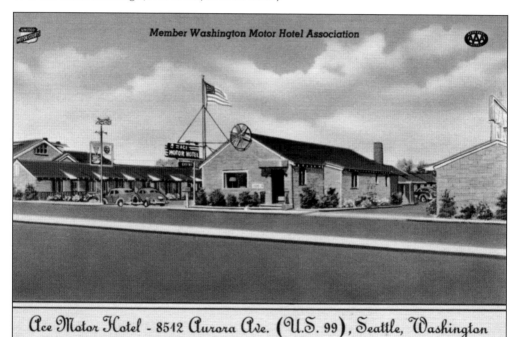

Ace Motor Hotel, an early arrival on the Seattle motel scene at 8512 Aurora Avenue, dates to about 1936 (when it was associated with the National Auto Villages chain). Arranged in a U-shape around a large central office building were 30 "elegantly furnished, modern, carpeted units," some with kitchens. Mr. and Mrs. Chas. W. Elicker owned and managed the Ace in 1948. The site is now a Travelodge.

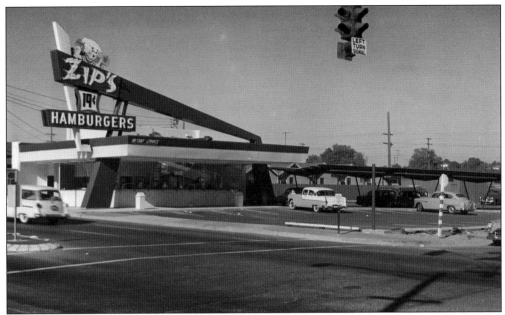

Zip's 19¢ Hamburgers, at 8502 Aurora Avenue, first appears in the Seattle telephone directory in 1956. Although targeting the same market, this Zip's does not seem to have been connected with the chain of Zip's Drive-ins started by Robert "Zip" Zuber in Kennewick in 1953, which had different signage. A Jack in the Box now occupies the site. (SPL.)

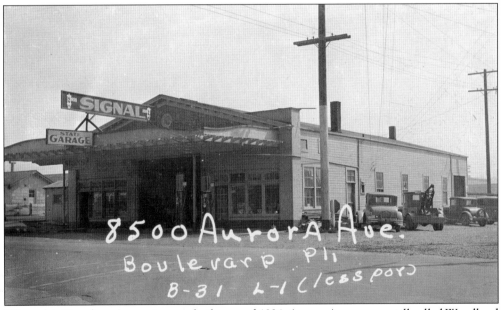

When this Signal service station was built around 1924, Aurora Avenue was still called Woodland Park Avenue, Seattle's city limit was N 85th Street, and businesses were only beginning to appear in the north end. Things were about to change; the 1926 completion of the Seattle-Everett Highway (the route of Aurora Avenue) and its designation as Federal Highway 99 accelerated roadside development. (WSA-PSR, 099930-1805.)

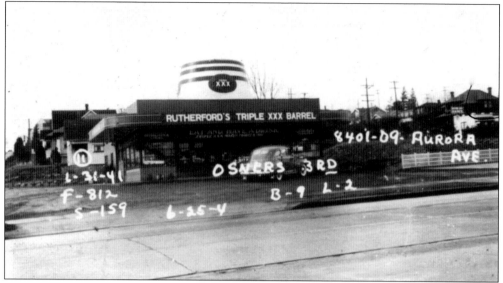

Another of H.J. Rutherford's Triple XXX Barrels opened in April 1940, at 8401 Aurora Avenue. Hours were 10:00 a.m. to 2:00 a.m.; a staff of a dozen orange-and-black uniformed employees provided booth and car service. Triple XXX was the brand of the Southern Beverage Company, formerly the Galveston Brewing Company; the name (and product) change resulted from Texas's 1916 prohibition of liquor. (WSA-PSR, 643100-0605.)

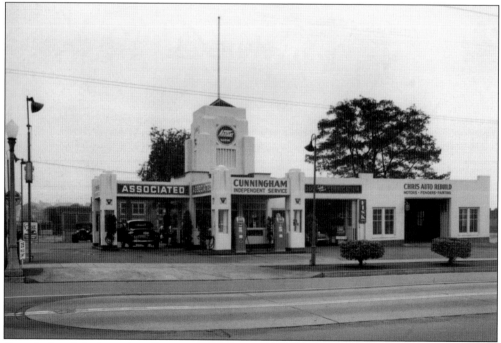

Cunningham's Independent Service at 7918 Aurora Avenue was first listed in the 1938 Seattle business directory and remained under ownership of William Cunningham for the next 20 years. This is how it looked in 1946. With its tower, mast, and multiple service bays, the building is a prime example of Art Deco modernistic design and is still in use, although not as a service station. (MOHAI, 1983.10.16329.2.)

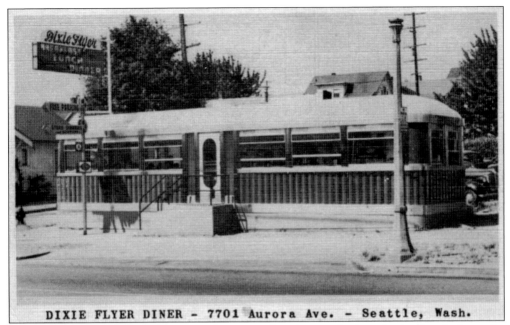

DIXIE FLYER DINER - 7701 Aurora Ave. - Seattle, Wash.

The Dixie Flyer Diner, at 7701 Aurora Avenue in Seattle, was the first classic diner built on the West Coast. A 1946 Kullman steel-and-porcelain beauty, it was owned and operated by Clifton and Edna Prichett until 1955, when it was purchased by Andrew Nagy of Andy's Diner and renamed Andy's Diner Too. In 1958, the structure was moved through downtown Seattle to a new site on 4th Avenue S.

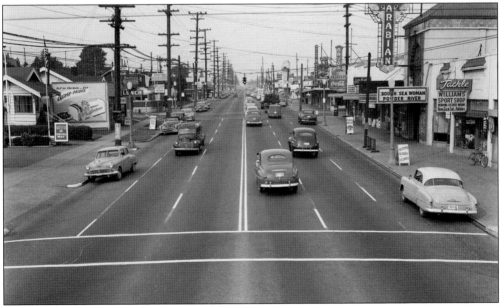

Aurora Avenue was bustling with automobiles (but few pedestrians) when this photograph was taken on October 6, 1953. Looking north, the Arabian Theatre is on the right, Bartell Drug's tower is seen in the middle, and the Dixie Flyer Diner can be made out on the left side behind a telephone pole. An array of neon signs crowds the streets, advertising lunch places, appliance shops, drugstores, and sports shops. (SMA, 44681.)

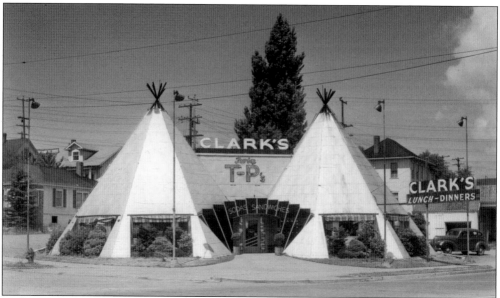

The Twin T-P's, possibly the finest example of roadside architecture in the state, opened in March 1937. It went through a succession of operators and, by the time of this 1942 photograph, was part of the Clark's chain. The dining room was in one teepee, the kitchen and lounge in the other. Interior decoration was Northwest Indian motif. After fires in 1997 and 2000, the Twin T-P's fell to the bulldozers in 2001. (MOHAI, 1983.10.17115.1)

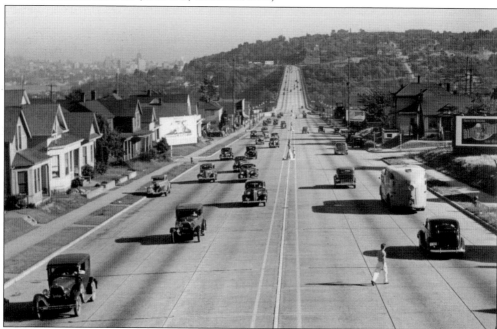

This c. 1937 image shows a southbound view of six-lane Aurora Avenue, looking toward the recently completed George Washington Bridge, with the skyline of Seattle about two miles away. A double-decked bus is visible in the right-hand lane. This section of Aurora Avenue was still residential at the time; within a few years, it would become small businesses intermixed with motels and other roadside services. (MOHAI, 2002.3.1431.)

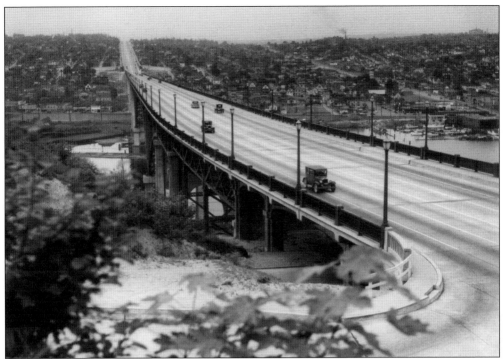

The George Washington Memorial Bridge (familiarly called the Aurora Bridge) carries Highway 99 traffic across the Ship Canal. The bridge was a major improvement in access to and through Seattle, previous routes having utilized a network of surface-level streets and bridges. With the dedication of the bridge on February 22, 1932 (the 200th anniversary of George Washington's birth), the Pacific Highway was considered complete from Canada to Mexico. (MOHAI, SHS7289.)

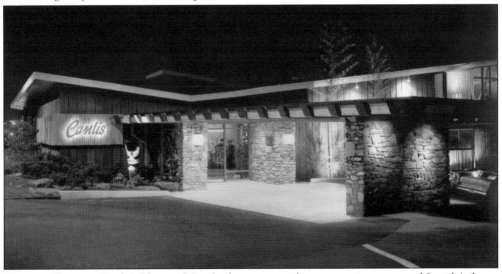

For over 60 years, Canlis' Charcoal Broiler has preserved its reputation as one of Seattle's finest restaurants. Designed by Roland Terry, the restaurant is located at 2576 Aurora Avenue south of the George Washington Bridge. Today, it is simply known as Canlis. With outstanding cuisine and spectacular views over Lake Union, Canlis is a world away from the burger joints lining Aurora Avenue further north. (MOHAI, 1986.5.11345.1.)

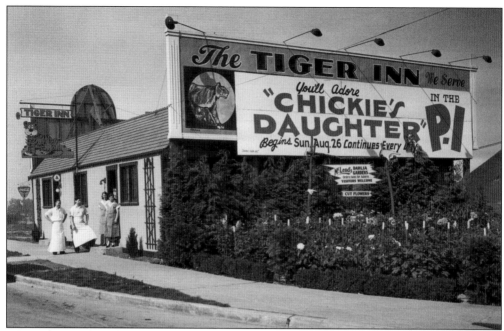

The Tiger Inn, at 2556 Aurora Avenue, was one of the early businesses to take advantage of traffic flow over the new George Washington Bridge. In 1932, it was owned by Mrs. N.H. Dahl. Specialties included "superb hot roast beef," chili, and hamburgers. By 1936, the location had been taken over by the Aurora Furniture Company. (MOHAI, 1986.5.11401.1.)

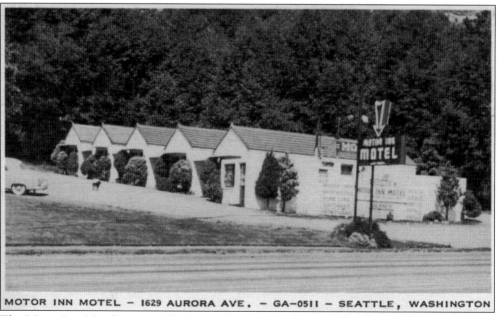

MOTOR INN MOTEL — 1629 AURORA AVE. — GA-0511 — SEATTLE, WASHINGTON

The Motor Inn Motel was at 1629 Aurora Avenue on the east side of Queen Anne Hill, just north of where the highway entered the city. Built in 1939 by Horace Tarbox, who passed away shortly after it opened, in 1940 it was owned by George Dexter. The Motor Inn consisted of 10 detached cottages tucked into a wooded enclave off the highway. It was demolished in the 1980s. (WSA-PSR, 192504-9024.)

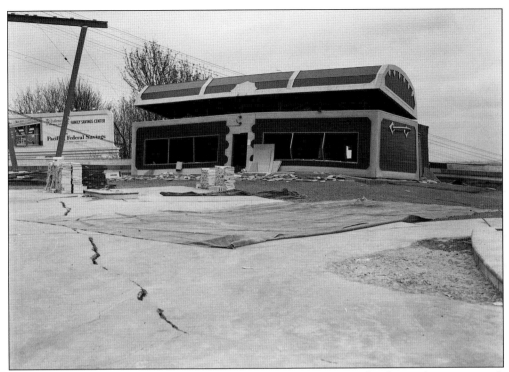

It would have been a prime roadside attraction: a service station in the shape of a giant pirate's treasure chest, complete with handles and "hinged" roof, perched alongside Highway 99 at Galer Street north of downtown Seattle. Unfortunately, it was not to be—the landfill on which the Treasure Chest was built collapsed during heavy rains in April 1957, and the station (shown here being demolished) never opened. (SMA, 54358.)

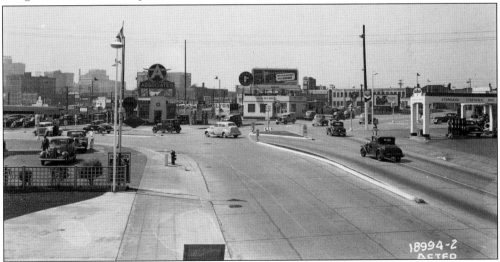

Southbound motorists on Aurora Avenue in 1940 could have no doubt that they were about to enter the big city when they reached the intersection with Denny Way. Six service stations and plenty of traffic are visible in this photograph. The highway made a shallow left turn to follow 7th Avenue to Westlake Avenue and into downtown Seattle, seen looming in the background. (SMA, 54495.)

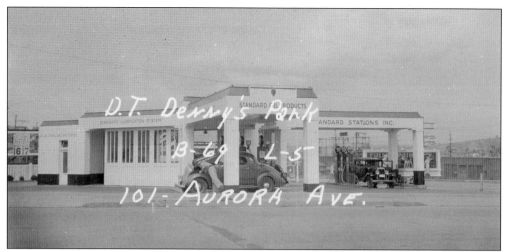

This image shows the Standard Station that was visible in the extreme right of the preceding photograph. Built in 1934, shortly before the Aurora Avenue-Denny Avenue intersection was revamped to facilitate traffic flow, the building is a fine example of 1930s urban service-station architecture, with two canopied pump bays forming a 'Y' and facing the principal streets and an office and service bay located at the stem of the 'Y'. (WSA-PSR, 54495.)

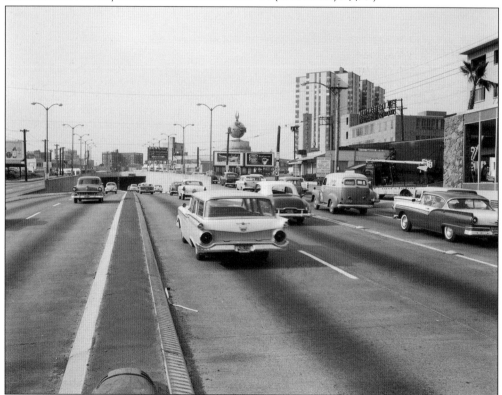

The scene at the same intersection had changed dramatically by 1959, when this photograph was taken. Rather than proceeding into downtown Seattle on surface streets, Highway 99 traffic went under the city via the Battery Street Subway and onto the Alaskan Way Viaduct. The *Seattle Post-Intelligencer* globe can be seen in the center background. (SMA, 61698.)

Three

SEATTLE TO TACOMA

For decades, Aurora Avenue ended at Denny Way. From that junction, Highway 99 angled southwest along 7th Avenue to Westlake Avenue and turned south to an intersection with 4th Avenue. Passing through Seattle's central business district on 4th Avenue S, the highway merged with E Marginal Way and followed it out of the city.

As early as 1939, city traffic had approached saturation. All north–south streets in Seattle between Alaskan Way and Boren Avenue were jammed to capacity. Studies showed that a solution was needed to expedite traffic, much of which was simply passing through downtown with no intent to stop.

Construction of a by-pass began in 1950. By 1954, through traffic was carried beneath Battery Street from Denny Way to 1st Avenue, then along the waterfront on the two-deck Alaskan Way Viaduct to E Marginal Way. The highway then followed E Marginal Way at surface level past its junction with 4th Avenue S (now no longer part of Highway 99) and on south.

Various early routes, including Rainier Avenue via Renton, took traffic south from Seattle. The Pacific Highway to Tacoma was officially dedicated in January 1915. The brick-paved route proceeded to Renton Junction, where it turned south down the Green River Valley on what is now the West Valley Freeway. At a point north of Sumner, it turned northwest and followed the Puyallup River into Tacoma.

In 1926, construction began on the Seattle-Tacoma Highway. Known as the Highline Route because it took to the hills to avoid the often-flooded valley, the new highway diverged from the old at a point just north of the Duwamish River.

As with the area between Seattle and Everett, the new route passed through undeveloped country—standing timber, logged-off land, and farms (massive development around SeaTac Airport did not happen until the late 1940s). Also like the Everett-Seattle reach, roadhouses were among the first businesses to appear along the new highway, though their reputation far surpassed those of their counterparts north of Seattle.

Highway 99, alternately called Pacific Highway S, passed west of Milton and through Fife. Crossing the Puyallup River Bridge, the highway entered Tacoma on Puyallup Avenue south of the business district.

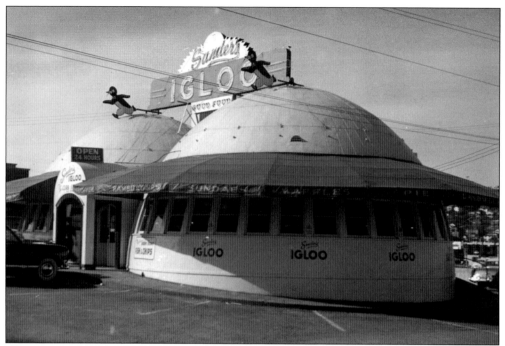

The Igloo, with its twin domes, marching penguins, and distinctive sign, attracted the attention of motorists on busy Highway 99. Located just west of Aurora Avenue at 6th Avenue and Denny Way, the Igloo offered table seating as well as drive-in and carhop service; it operated from late 1940 until about 1954, when it was removed to make way for Aurora Avenue access ramps. (SPL.)

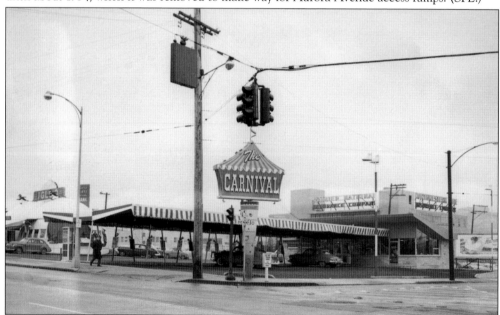

In 1954, the Carnival Drive-In took the place of the Standard Station at 101 Aurora Avenue. This photograph—showing both the Carnival, with its canopied carhop area, and the Igloo in the background—was taken during the very short time that the two restaurants coexisted. Unfortunately, the Carnival soon met the same fate as the Igloo; it, too, is now gone. (SPL.)

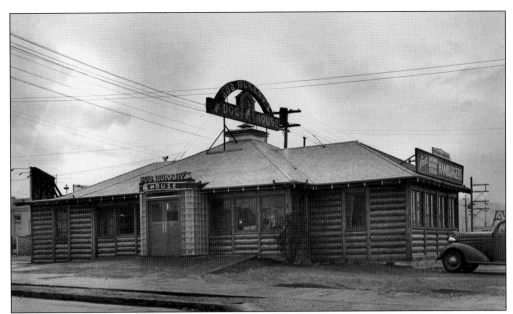

The Dog House was situated at 714 Denny Way, convenient to traffic heading into or out of the city on Highway 99. Opened by Bob Murray in 1934, the restaurant-cocktail bar was famous for 24-hour food, fun, and drinks. The building was acquired by the Odman brothers when Murray relocated to 7th Avenue in the 1950s. The relocated Dog House closed in 1994; the original building is gone. (MOHAI , 1986.5.11356.)

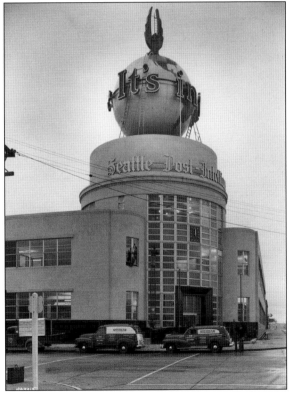

A tour de force of Art Moderne, streamlined design, the *Seattle Post-Intelligencer* Building is shown in 1948, shortly after its completion. Its thirty-foot-diameter globe—neon-lit, topped by a stylized eagle, and encircled by the words "it's in the P-I"—was a beacon for travelers entering the city from the north. The globe outlived the print edition of the *P-I* (publication ceased in 2009) and has been preserved. (MOHAI, 1983.10.16879.2.)

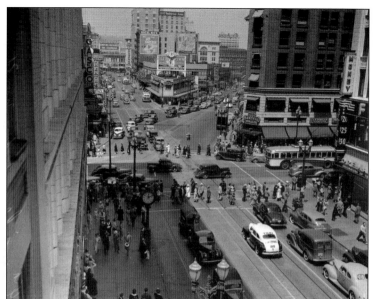

It is 12:10 on a busy June 1942 afternoon in downtown Seattle. This view looks northwest to the intersection of Westlake Avenue and 4th Avenue; Westlake is the diagonal street entering in the upper right. From this intersection, 4th Avenue carried Highway 99 through the city and on toward the south. (MOHAI, 1986.5.12358.)

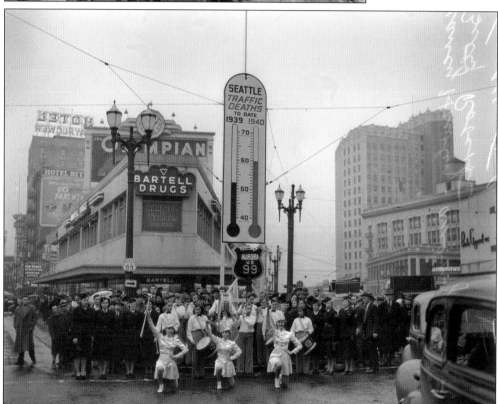

In 1940, Drum majorettes, a band, and stiffly uniformed officials celebrate at the Westlake Avenue and 4th Avenue intersection beneath a sign recording the number of traffic deaths. The exact cause for celebration is unclear, since the "death thermometer" shows a higher fatality rate for 1940 than for 1939, but everybody appears to be having a good time. Highway 99 signs point the way to Aurora Avenue for northbound motorists. (MOHAI, 1986.5.15092.1.)

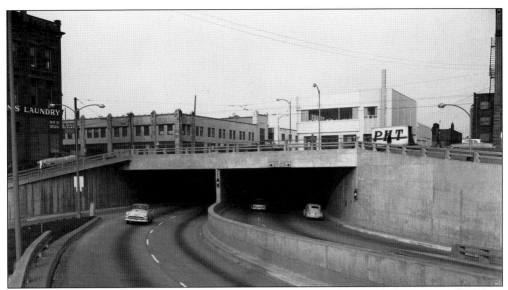

The Battery Street Subway was only a few years old when this photograph was taken in 1956. The Subway (usually called "the Tunnel," though "subway" is more accurate—it is not actually underground, as its ceiling is formed by surface-level Battery Street) was part of the Alaskan Way Viaduct project but was not completed until a year later. When opened, it connected Aurora Avenue traffic with the viaduct.

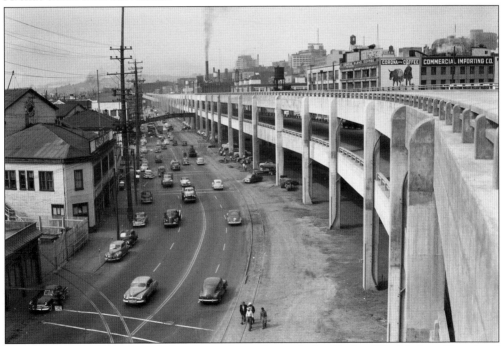

For nearly 60 years, Seattle had a love/hate relationship with the Alaskan Way Viaduct. Completed in April 1953, the viaduct changed the flow of Highway 99 traffic—no longer through the city, but under (via the Battery Street Tunnel) and around. But many felt the "great wall" isolated the city from its waterfront. In 2012, about to be replaced by deep-bore tunnel, the viaduct started coming down. (SMA, 62241.)

By 1959, the bypass of downtown Seattle via the Battery Street Tunnel and the Alaskan Way Viaduct, with its southern extension shown here, was complete. The new highway merged onto E Marginal Way about a mile south of the city. After 4th Avenue S was no longer the main line of travel south of the city, it lost its Highway 99 designation in favor of the new route. (SMA, 62951.)

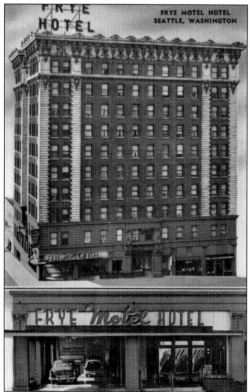

When constructed in 1911, the Frye Hotel was considered to be Seattle's finest. Its site adjacent to the train depots at the south end of Seattle's business district attracted railroad travelers. In the 1950s, the hotel updated its image by billing itself as the Frye Motel Hotel, adding a separate check-in parking area for the convenience of motorists. The Frye has since been converted to low-income apartments.

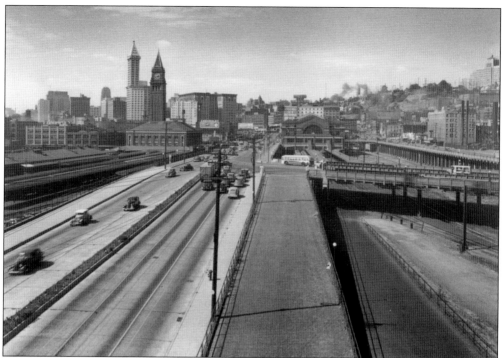

Highway 99 exited Seattle southbound on 4th Avenue S in 1945. Visible is the Smith Tower, which was completed in 1914 and, until 1962, was the tallest building west of the Mississippi River. The clock tower of King Street Station (serving the Great Northern and Northern Pacific Railways) is to its east; across the street is Union Station. The Frye Hotel is just north of King Street Station. (MOHAI, SHS6141.)

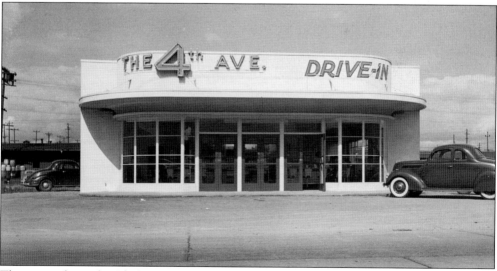

This image shows the 4th Avenue Drive-In, located at 1245 4th Avenue S, shortly after it opened in 1940. The restaurant was open for breakfast, lunch, and dinner and had curb service as well as fountain and booth seating. Advertisements for the drive-in touted "the home-cooked flavor of [its] food" and reasonable prices. The drive-in survived into the late 1950s; its site is now under an Interstate 90 access ramp. (SMA, 18872.)

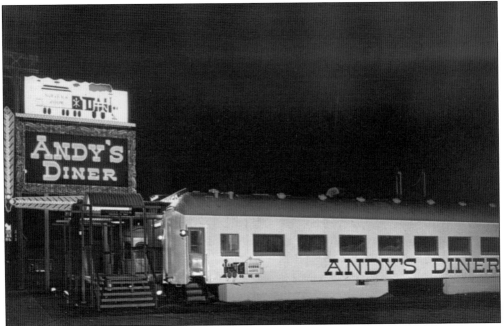

In 1949, Andrew Nagy bought a steel-sided railroad dining car, removed the wheels, and fitted it up as Andy's Diner at 2711 4th Avenue S in Seattle. Andy's moved a few blocks south to 2963 4th Avenue S and grew into a complex of half a dozen recycled railroad cars. Andy's closed in 2008; the Orient Express took its place.

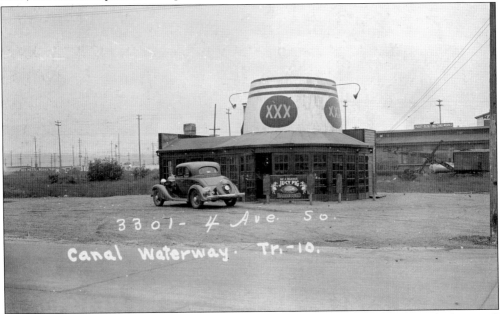

An early example of Triple XXX Barrel architecture, this version was at 3301 4th Avenue S on land owned by the Port of Seattle. The photograph is from 1937, but the Barrel had been in business for several years by that date. At the time, the location was the fringe of Seattle's industrial area. In addition to root beer, Triple XXX introduced Seattle to "Ju-cy Pig Barbecue" sandwiches. (SA-PSR, 132730-0013.)

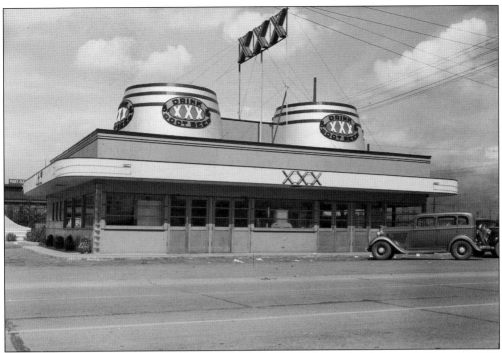

In 1940, H.J. Rutherford and business partner O.A. Kuehnoel replaced the early Barrel at 3301 4th Avenue S with a new restaurant—another example of their trademark Triple XXX design featuring a giant barrel on the roof. Rutherford was Triple XXX's largest distributor and designed the restaurants' barrel motif. He also owned several Triple XXXs in Spokane, while Kuehnoel owned at least one other outlet in Seattle. (SMA, 18871.)

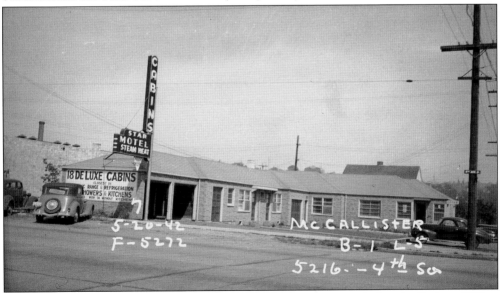

The Star Motel was one the earliest tourist accommodations in south Seattle. Built in 1941 at 5216 4th Avenue S, it was "closest in" to the city, offering 18 cabins (all with showers, some with kitchens, and a few with garages). Heavily remodeled in 1967, at which time a third wing was added along the highway, the Star is still in business. (WSA-PSR, 526330-0025.)

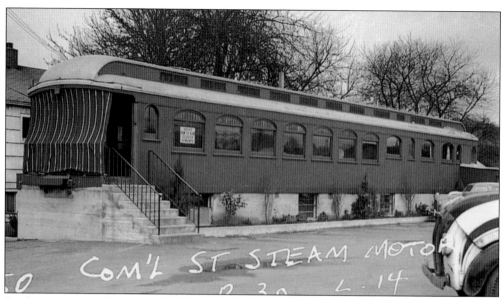

Farther south on 4th Avenue was another diner, Knight's. Brothers Frank and Jack Knight purchased an observation car from the Northern Pacific and opened Knight's Diner in Spokane in 1931. A few years later, Frank moved to Seattle and repeated the process. The Seattle Knight's opened in 1938 at 6159 4th Avenue S. In the 1980s, the car was moved to Spokane, where it now operates as Frank's Diner. (PSRA.)

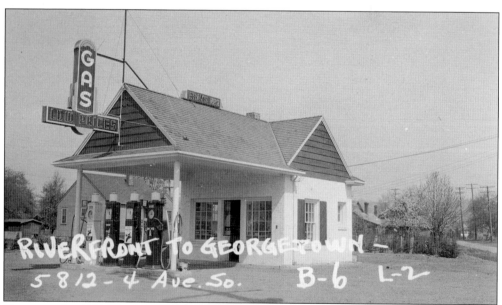

Constructed in 1936, Wray's Service Station represented an emerging trend in service-station styling. Stations began to look like small cottages, both to better blend into residential neighborhoods and to lessen their industrial appearance so as to attract the ever-growing number of women drivers. Wray's featured four pumps of Texaco Fire Chief gasoline but had no service bays. It was gone by 1945. (WSA-PSR, 278310-0260.)

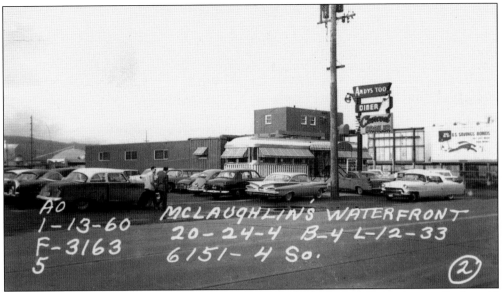

Andy's Diner Too, the ex-Dixie Flyer, is shown in its new location at 6151 4th Avenue S, about 10 miles south of its original site and two miles south of the other Andy's. The structure underwent several modifications, including a 20-by-50-foot dining room added to the original diner in 1960. The diner operated in this location until about 1963, when it was again moved and later demolished. (PSRA.)

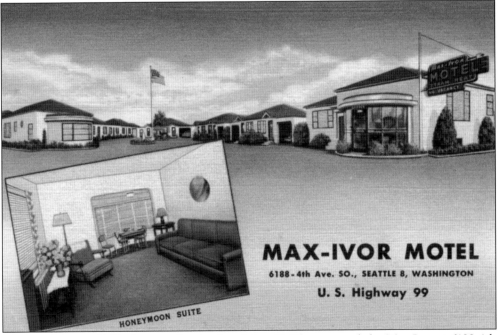

Max was Maxine Bebb; Ivor was her husband, Ivor E. They opened the Max-Ivor at 6188 4th Avenue S in the 1940s. It boasted 20 furnished suites, maid service, steam heat, private baths and showers, radios, and refrigerators. After Maxine passed away in 1952, Ivor continued to operate the motel, adding additional units over time. Now called the Martin Court, it is in use as transitional housing for the homeless.

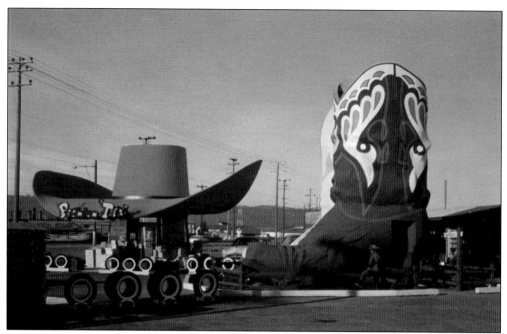

Its real name was Premium Tex, but everybody knew it as "Hat n' Boots." The giant cowboy hat (gas station) and boots (restrooms) were built in 1954 for a planned (but never constructed) frontier-village-themed shopping center along E Marginal Way near Boeing Field. The station closed in 1988. After the hat and boots were vandalized, the City of Seattle moved and restored them in a local park. (JCO'D.)

The Chief Seattle Motel was one of a cluster of roadside businesses located a half-mile south of where 4th Avenue S turned onto E Marginal Way. The Chief Seattle was built in 1950 and consisted of with 11 units in an L-shaped configuration. The subdued appearance of the motel's concrete-block walls was offset by a resplendent neon sign bearing the profile of an Indian chief in full headdress. (WSA-PSR, 273410-0245.)

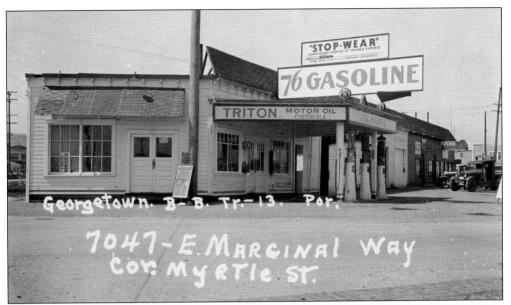

Joe Borghes owned this 76 Gasoline station in 1928, though judging from its appearance it dates to an earlier era. It was located just across the highway from the Chief Seattle Motel and the Munson Motor Court. By 1939 the station was owned by Walter Bourdage. The Camel Cafe occupied the northern portion of the building. (WSA-PSR, 273410-0260.)

This restaurant at 7047 E Marginal Way went by a number of names over the years—it was Chat & Chew Cafe in 1930, Leo's Cafe in 1934, and Pat's Place in 1937—before finally becoming the Camel Inn, under which name it operated for another 30 years. Located across from two motels and convenient for travelers, the Camel also catered to workers of nearby industries. (WSA-PSR, 2734100260.)

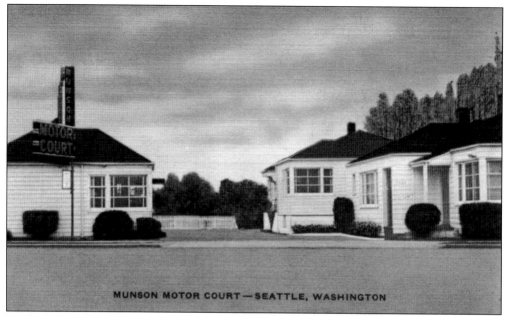

MUNSON MOTOR COURT — SEATTLE, WASHINGTON

Munson Motor Court was located adjacent to the Chief Seattle at 7060 E Marginal Way. Opening in 1941 as the Armstrong Motor Court, Munson's accommodations were 10 semidetached cottages (some with kitchens) surrounded by neatly trimmed hedges and a picket fence. Munson's advertised its proximity to both downtown Seattle and the rapidly expanding Boeing aircraft plant a few blocks away.

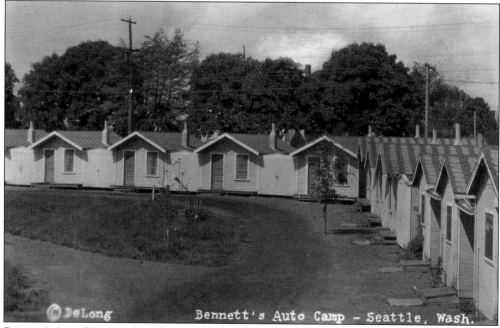

Bennett's Auto Camp — Seattle, Wash.

Bennett's Auto Camp made its first appearance in the Seattle business directory in 1929. The camp was located on four acres in an undeveloped area south of the city and consisted of 42 AA and A cabins, some with showers and kitchens, at rates of $1 and up. Tent campsites were available, and a community recreation hall was provided.

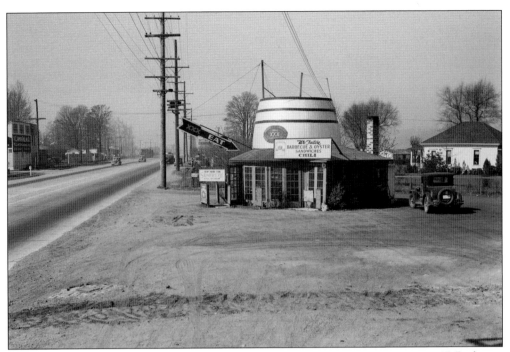

Another early Triple XXX Barrel was located at 9422 E Marginal Way from 1934 to 1937. Barbecue and oyster sandwiches, chili, and Sunfreeze ice cream were featured menu items. By 1941, the Barrel had been replaced by the Little Red School House Cafe, which in turn was replaced by a gas station. The site is now part of Boeing Field. (SMA, 10242.)

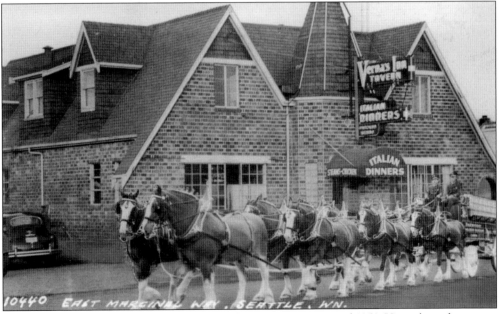

Verna's Inn Tavern opened at 10440 E Marginal Way sometime around 1950. Housed in a distinctive brick building, Verna's specialized in Italian and American dinners and was open daily from 11:00 a.m. to 11:00 p.m. The horses and wagon in this photograph are the Clydesdales of Budweiser Beer fame. Solidly built though it was, Verna's had disappeared by 1970.

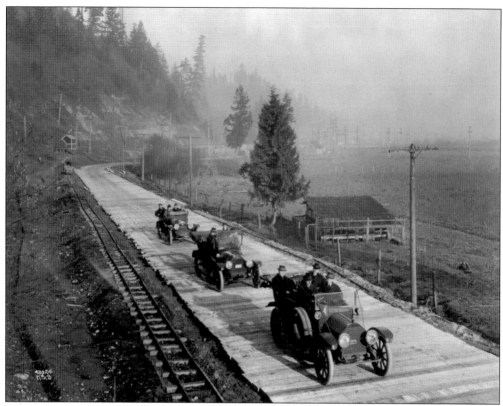

Three groups of automobilists from the Tacoma and Seattle Auto Clubs celebrate the opening of the newly completed section of highway between the two cities on January 29, 1915. While much of the highway was brick—claimed to be the first stretch of brick-paved highway west of the Rocky Mountains—the portion shown here is covered with planks. Today, the West Valley Highway follows the same route. (MOHAI, 441.)

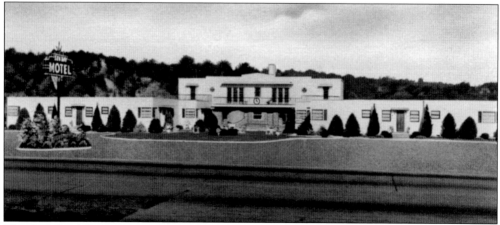

The Sun Ray Motel, at 10830 South Pacific Highway S, had a history of frequently changing hands. Owned by Mr. and Mrs. T.H. Hames in 1944, it was traded to Mr. and Mrs. William Holzemer for an apartment building in 1954, traded yet again in 1955 to Mr. and Mrs. Elazar Behar, and purchased by Jay Krom in 1966. Development south of Boeing Field has swallowed up the 21-unit motel.

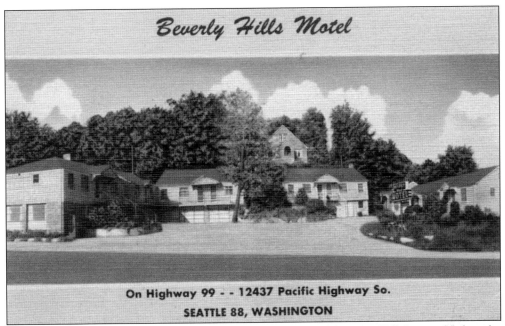

Beverly Hills Motel

On Highway 99 - - 12437 Pacific Highway So.
SEATTLE 88, WASHINGTON

Mr. and Mrs. Ted Nakkerud opened the Beverly Motel around 1942; "Hills" was added to the name sometime later. The motel was located at 12437 Pacific Highway S, perched along the west side of the highway with a view over the Duwamish River flats. As early as 1954, their business emphasized weekly rates, though they still catered to the tourist trade. Today, the buildings are in use as apartments.

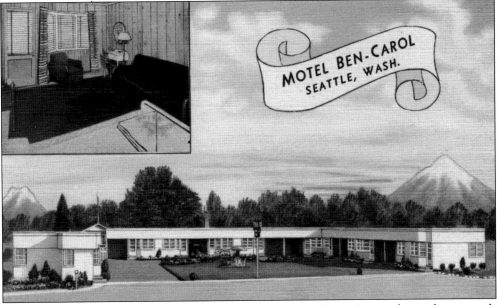

The Motel Ben-Carol opened around 1948 at 14110 Pacific Highway S, one of several new motels built between downtown Seattle and recently opened Seattle-Tacoma International Airport. The Ben-Carol's 25 units provided "the finest of accommodations," with Simmons beds, Beautyrest mattresses, tiled showers and tubs, and private garages. The motel has been heavily altered and is now a Knights Inn.

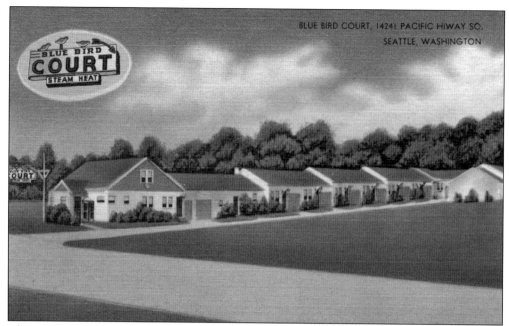

The 19-unit Blue Bird Court, located across the street from the Ben-Carol at 14241 Pacific Highway S, was another motel in the rapidly developing area near the new airport. Apartments and "sleeping rooms" were offered, with electric kitchens, radio, and TV. John Kruse operated the court from 1954 until his death in January 1956; Mrs. Kruse sold the property in June 1957. The site is now a Jet Inn.

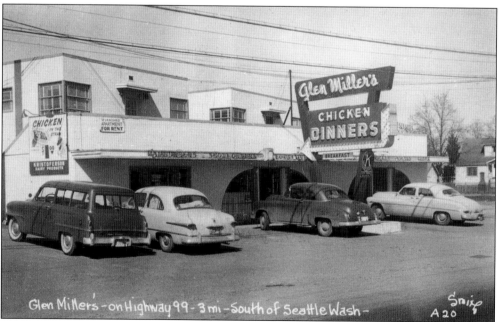

Rector's Double E Inn opened at 14835 Pacific Highway S sometime prior to 1948; in that year, it was owned by Earl Jones. By 1952, the restaurant had become Glen Miller's Chicken Inn, specializing in "chicken in the straw." Steak and pork chop dinners were also on the menu, as well as breakfast options, hamburgers, and other short order items. Miller's operated into the 1960s.

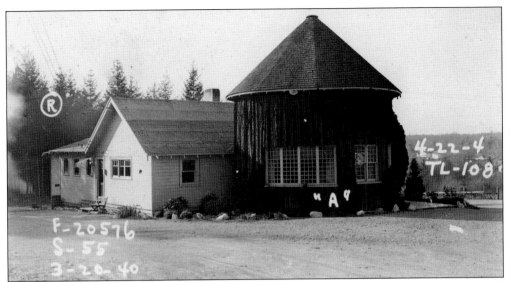

The Big Tree Inn, originally an attraction at the 1915 Panama Pacific International Exposition in San Francisco, was constructed from two sections of a 200-year-old, 300-foot-tall redwood tree. It was transported to Des Moines and opened about 1920 on an early road between Seattle and Tacoma. It was operated by Andrew and Katherine Swanson, who purchased it from A.E. Hughes in 1922. (WSA-PSR, 042204-9108.)

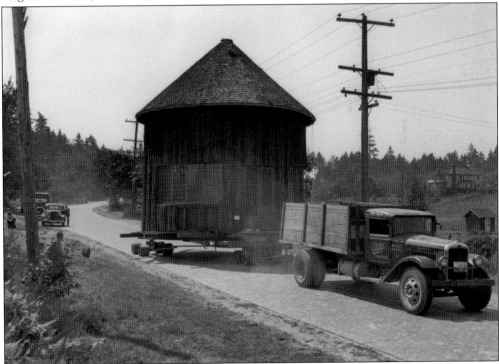

After the Seattle-Tacoma Highway was constructed a few miles away, the Big Tree Inn was hoisted onto a flatbed truck and hauled to its new location at 19207 Pacific Highway S. It became a destination resort, famous for Mrs. Swanson's chicken and steak dinners. The Swansons sold the business to E.R. Kennedy in 1944; fire destroyed the building in May 1946. (MOHAI, 1986.5.1056.2.)

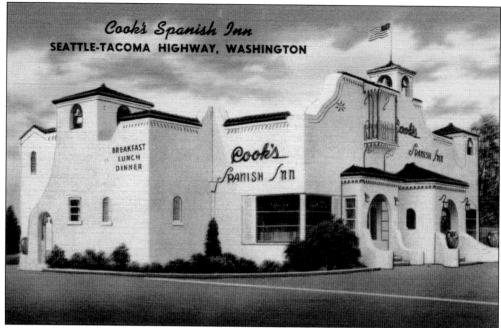

Cook's Spanish Inn, opened in 1948, claimed it was the only place north of San Francisco where one could find Mexican dishes, such as enchiladas, tamales, tortillas, and tacos. Cook's chefs also pioneered fusion cuisine—Chinese fried shrimp, chow mein, and chop suey were on the menu, too. The Mission-style building at 20011 Pacific Highway S in Des Moines currently houses the Bull Pen restaurant.

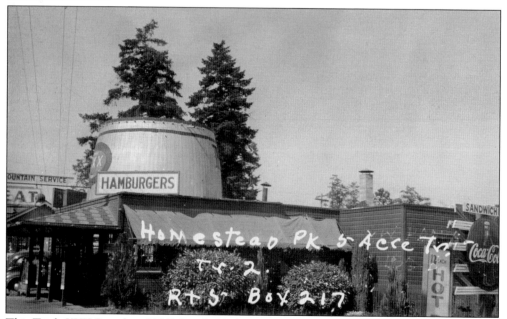

This Triple XXX Barrel, at 20012 Pacific Highway S near Angle Lake, first appears on record in 1938, but from its appearance seems to have been built around 1930. In September 1952, when it was under the ownership of Sarkies J. Michael, the restaurant was destroyed in a fire caused by faulty wiring. The loss was estimated at $18,000. (WSA-PSR, 344500-0018.)

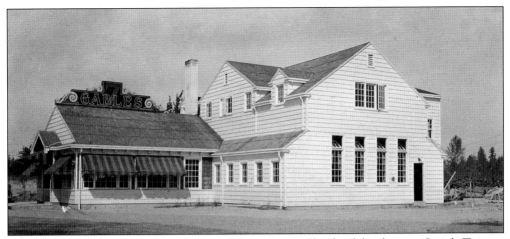

After Lebanese immigrant Sam Hassen sold a portion of his land for the new Seattle-Tacoma Highway in 1926, he built a gas station along the highway. In 1935, he constructed the popular Seven Gables Inn, a combination restaurant, bar, and dance hall at 20842 Pacific Highway S. After Sam passed away in 1956, his son William ran the business until it was sold in 1961. The building still stands. (WSA-PSR, 092204-9288.)

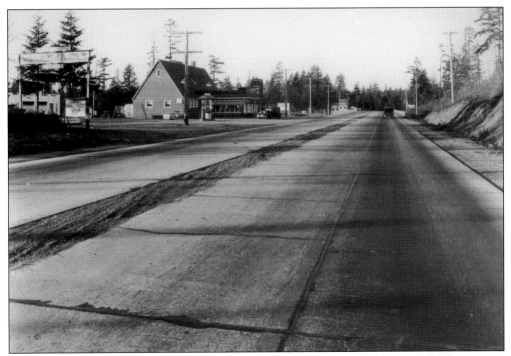

Traveling the Seattle-Tacoma highway was an adventure in the early days. To city-bred motorists, the route must have seemed an empty wilderness; services were few and far between, as this c. 1931 view looking north in Des Moines shows. The Half Way House on the left and a Texaco gas station tucked among the tall trees farther up the road would have been welcome sights for the weary traveler. (TPL, 120.)

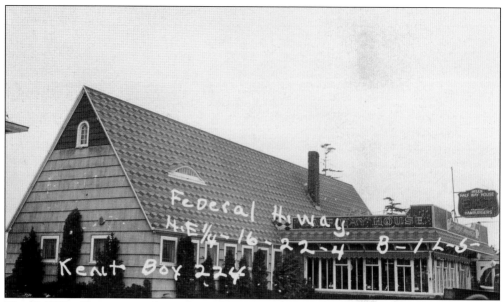

The Half Way House was at the midpoint between Seattle and Tacoma. In addition to steak and oyster dinners and famous 10¢ hamburgers, the inn had two gas pumps and a garage to assist motorists in trouble. Cabins were available just up the highway. The Half Way House was located at 22603 Pacific Highway S and survived into the 1950s. (WSA-PSR, 250060-0025.)

Highway 99 approaches the busy Kent-Des Moines Road intersection in this view looking south. The Spanish Castle, a popular spot for ballroom dancing dating from the 1930s, is on the right; a fountain lunch, a service station, and other roadside businesses can be seen on the left shoulder. (RKE.)

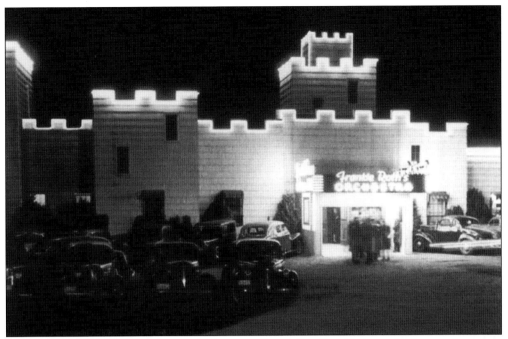

The Spanish Castle became famous for having a "good floor" and being safe: dress and conduct codes were strictly enforced. As many as 2,000 people packed the place on Saturday nights. Times changed, however; by the mid-1960s, the mellifluous strains of Frankie Roth's Orchestra had given way to the innovative guitar work of Jimi Hendrix. The building is now gone. (DMHS.)

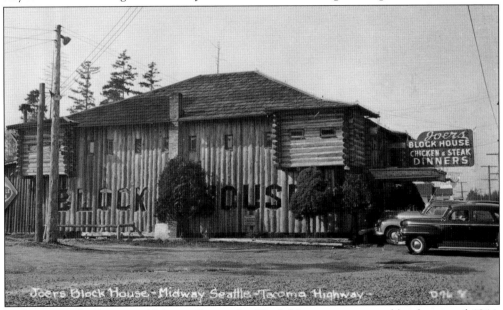

Built in 1933 for Ernest and Minnie Foster, the Block House was operated by them until 1944, when they sold it to Paul and Frances Joers. The original log building, located at 22855 Pacific Highway S, burned down in 1953, was rebuilt two months later, and was completely remodeled in 1967. After Joers's death, his daughter Marilyn and her husband ran the restaurant. A casino now occupies the site.

In 1937, the Fireside Inn occupied the building that had housed Bishop's Rotisserie at 23826 Pacific Highway S. Contemporary views show a well-built, rustic log structure with a large covered porch and two cobblestone chimneys. For over 50 years, the Fireside Inn was a popular spot along the highway for breakfast, lunch, and dinner. The building is still in use, currently as JJ's Bar & Grill. (WSA-PSR, 250060-0541.)

Rose Wilcox opened her namesake Highway Inn at 26915 Pacific Highway S in 1939. Rose served only "the best home-cooked food"; her menu featured chicken, steak, and ham dinners. She sold the roadside dinner house in the 1970s, with the condition that the restaurant must retain its old-fashioned appeal. Rose's was lost to fire in March 2003. (TPL, A8483-1.)

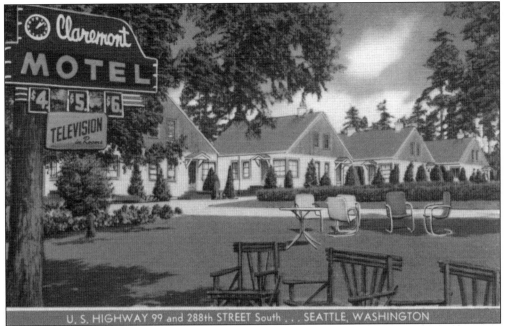

U. S. HIGHWAY 99 and 288th STREET South . . . SEATTLE, WASHINGTON

Originally known as the Corbett Apartment Motel, the Claremont Motel was owned by Seattle hotel man Bill Corbett. In 1951, Corbett sold the motel, and its name was changed. The Claremont Motel was located on Highway 99 at 288th Street S, overlooking Puget Sound between Seattle and Tacoma, and offered 48 units with air-conditioning and fireplaces. In later years, Mary and Martin Rasmussen owned and operated the motel.

Built around 1938, the Blue Jay Grill near Pacific Highway S and S 288th Street was a popular hamburger hangout for teens and young adults in the 1940s and 1950s. Robert and Ruth Miller operated the restaurant for 19 years before selling it to Arthur and Mary Anderson of Seattle; it was later owned by Bill Clinkenbeard, who also operated the Green Parrot Inn. (HSFW, 174a.2.)

Harold Hagen owned this early Shell gas station; his home was at the rear of the property. The substantial building on the right is Eastman Woodcraft. On the left was Pauline's Tavern, later to become the site of the Federal Way Variety Store. The location, on Pacific Highway S near S 314th Street, was known as the Federal Way Shopping Intersection. (HSFW, B389.)

Rocky Rockwell opened Rocky's Drive-In in 1948 at 31815 Pacific Highway S in the Federal Way district. Rocky's claimed to be the "Largest [drive-in] restaurant on Highway 99 between Seattle and Tacoma." One of the first restaurants in the area to feature carhop service, it stayed open from 7:00 a.m. until 3:00 a.m. for breakfast, lunch, and dinner. (HSFW, B726.)

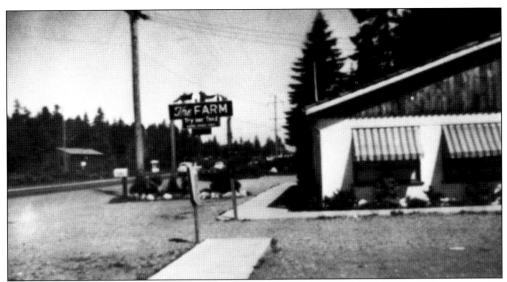

When Janice Koskivich and her husband took over The Farm Inn in 1943, the restaurant consisted of five mismatched tables housed in a small wooden building. Over the next 31 years, the Koskiviches expanded the restaurant numerous times as crowds were drawn in by fried chicken dinners and homemade pies. When Janice retired in 1983, The Farm became a Mexican restaurant; the building is now gone. (HSFW, 119 1443.)

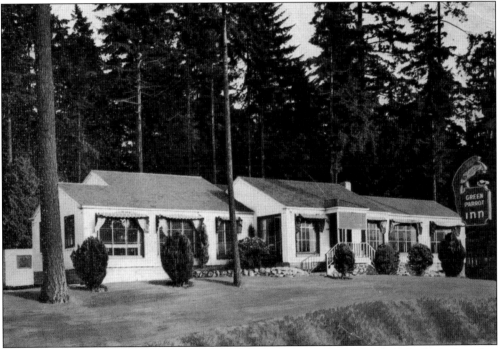

From the very beginning, J.O. Gates intended his Green Parrot Inn to be a notch above the other roadhouses along the Seattle-Tacoma Highway. Opened in the early 1930s, the Green Parrot was a dining-room restaurant with lace tablecloths, gleaming silverware, finger bowls, and flower-filled vases on the tables. A Depression-era chicken dinner—fried chicken; rice with giblet gravy; and baking powder biscuits, made fresh hourly—cost 65¢. (HSFW, B387.)

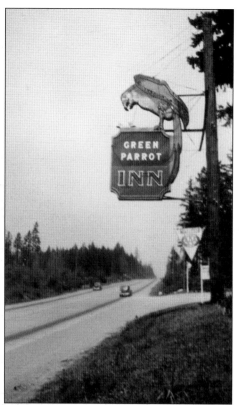

The Green Parrot's sign directed travelers to the family-style restaurant. Gates and wife Myrtle took pride in careful preparation of meals. Open for dinner daily, the price went up to $2 after the war, but included crab cocktail, soup, salad, dessert, and coffee. Gates sold the Inn after 15 years; subsequent owners included Mr. and Mrs. W.O. Clinkenbeard as well as Mr. and Mrs. H.A. Sutherland. The building burned in 1979. (HSFW, 197.4.)

This southbound view of a rainy Highway 99, approaching Tacoma, shows the Milton Tavern and a Texaco gas station on the east side of the highway and the Puyallup River valley just over the hill. The stretch of highway between Federal Way and Milton (the town of Milton is actually a mile to the east) remains relatively undeveloped even today. (TPL, D12209-7.)

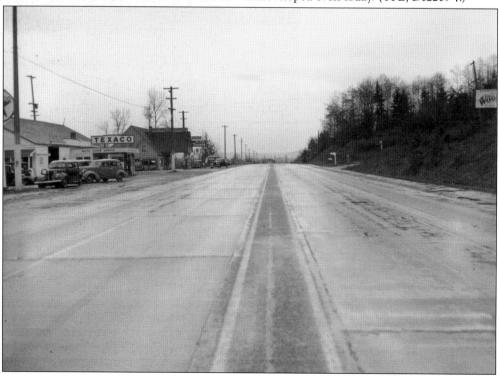

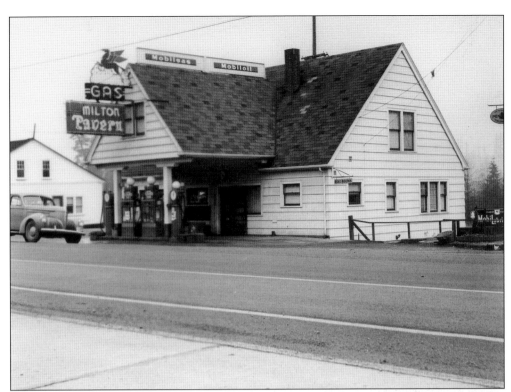

The Milton Tavern dates to at least 1941. In early days, it had a reputation as an upscale dining spot with lunch, beverages, and "service supreme." Mobilgas and lubrication were available. Over the years, the tavern devolved into a typical highway bar. Chris Guzek bought the tavern in 1987 and has refurbished and restored it to its former glory. (TPL, BU-12126.)

The Red Pig was a "smart dining spot" on the Tacoma-Seattle Highway half a mile north of Fife. Opened in May 1937 by Earl Smith, by October 1938, it was operated by Joe Fox and his sister-in-law Bernice Fox. The redecorated, renovated Red Pig was equipped with a variety of new electric appliances— including an electric cash register, a novelty at the time. The menu featured steak, chicken, and hamburgers. (TPL, A7529-4.)

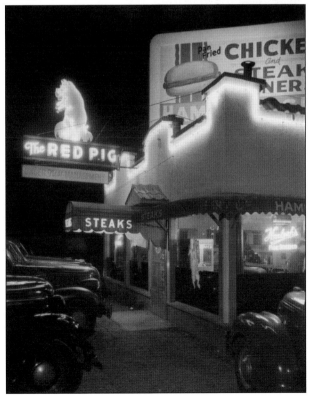

Looking both futuristic and grim in its unfinished state, the Century Ballroom in Fife opened its doors just in time for New Year's Eve, 1934. Many famous big bands, such as Tommy Dorsey and the Lombardos, played here. The Century fell victim to the times as ballroom dancing gave way to rock and roll; it closed in 1956, was used as a shopping mall for awhile, and finally burned in 1964. (TPL, 1032-1.)

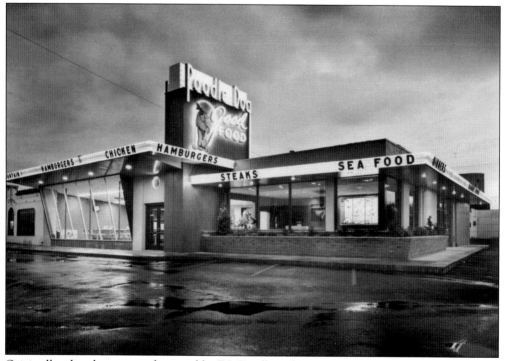

Originally a hamburger stand opened by E.J. Zarelli and Rocco Manza in 1933, the Poodle Dog has been rebuilt three times at the same location in Fife. This is the 1949 version of the building. Designed by Thomas Albert Smith, the modernistic restaurant featured a circular, stainless-steel counter, which allowed customers to watch their food being prepared. Huge glass windows gave a view onto Highway 99. (TPL, A45142-3.)

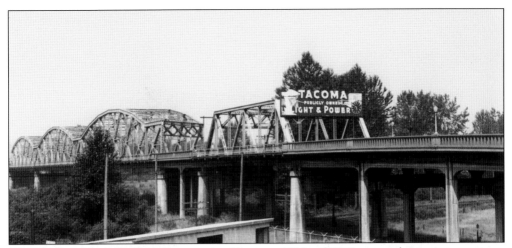

The Puyallup Avenue Bridge was constructed between 1926 and 1927 as part of major improvements to the Pacific Highway in Washington State. An early route followed a convoluted path across the Tacoma Tideflats before crossing the Puyallup River a half-mile southeast of the new bridge. When it opened in January 1927, the new bridge, with four lanes facilitating traffic flow, was cause for celebration in Tacoma. (TPL, D92066-1.)

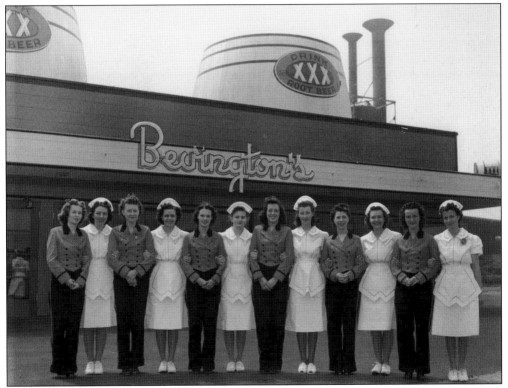

Dick Bevington opened this Triple XXX Barrel at 924 Puyallup Avenue in June 1940. The orange and black root beer drive-in, which was part of the rapidly expanding Triple XXX franchise and had been built at a cost of $29,000, featured counter service, booths, curb service by attractively uniformed carhops as well as parking for nearly 100 cars. The Bevingtons resided in an apartment at the rear of the premises. (TPL, D9841-4.)

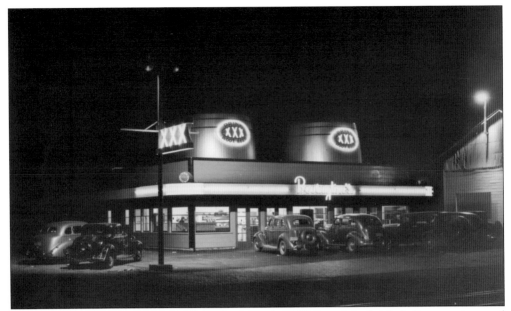

This image shows a night view of Bevington's Triple XXX Barrel. Its brightly lit neon signs and tubing, highlighting the iconic giant root beer barrels on its roof, and round-the-clock service were certain to attract drivers on the Seattle-Tacoma Highway, as Highway 99 was locally known. Though heavily remodeled, the building remained in service under the name Marilyn's until closing in 1999. (TPL, A9841-6.)

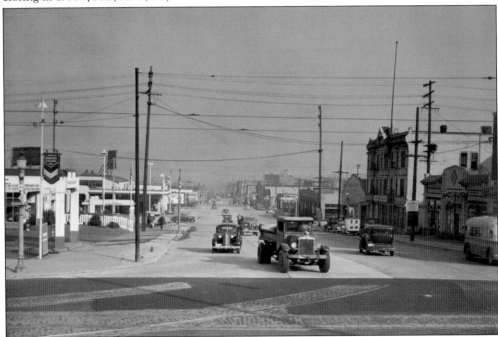

Puyallup Avenue was in the process of being modernized in this view from October 1938, looking east from Pacific Avenue. Streetcar tracks were being paved over with concrete as old forms of transportation gave way to new. Newly resurfaced, Puyallup Avenue brought Highway 99 traffic to an intersection with Pacific Avenue south of Tacoma's shopping district. (TPL, D7564-8.)

Four

TACOMA TO OLYMPIA

Highway 99 crossed Pacific Avenue about a mile south of Tacoma's central business district. Many travelers undoubtedly took advantage of the opportunity to tour downtown. An early route departed Tacoma via Jefferson Avenue to Tacoma Avenue, west on 38th Street, south again on M Street, west yet again on 56th Street to Union Avenue, and then turned south. Later construction took advantage of a natural gully, located one block off Jefferson Avenue, to funnel traffic uphill in a more direct line to a junction with Union Avenue.

Over time, the entire segment from Pacific Avenue to 108th Street SW, at the boundary between Tacoma and Lakewood, became known as South Tacoma Way. Centered near the intersection of South Tacoma Way and S 56th Street, the South Tacoma district was at one time second only to downtown Tacoma as a regional retail center.

The name of the highway reverts to Pacific Highway S at 108th Street SW. A few miles farther on at Ponders, Highway 99 disappears beneath Interstate 5 and remains buried for about 10 miles, passing the main gate of Fort Lewis and the community of Tillicum on the other side of the railroad tracks.

At the edge of the Nisqually River valley, the early Pacific Highway turned south and crossed the river about three miles upstream from the present twin bridges on the freeway. The old route angled westward to pass just north of Lacey and into Olympia on 4th Avenue E.

Around 1936, Highway 99 was rerouted to a more direct alignment between the Nisqually River and Olympia. A bridge built at that time continues to carry northbound freeway traffic. Just south of the bridges, Highway 99 followed Martin Way in a westerly course toward Olympia. The old and new routes met at a junction a mile east of downtown Olympia; both routes then took 4th Avenue E into the city.

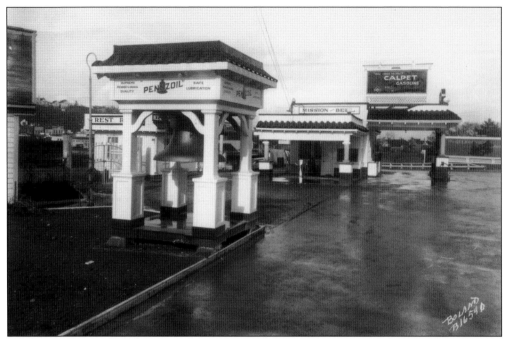

Architect Thomas B. Hall designed this fine Spanish Mission–style service station, which was built by Nettleton & Buck. Located at 1301 South Tacoma Way, the Mission Bell Service Station featured gasoline pumps and service bays with porticos; restrooms in a separate building; and, proudly displayed in this photograph, Tacoma's first fire bell. Opened in 1925, it was replaced by an Associated Service Station in 1939. Interstate 5 now covers the site. (TPL, BU-13102.)

The Coffee Pot, a longtime roadside icon, was prefabricated, hauled to 2102 South Tacoma Way, and assembled in place in 1927. In 1940, new owner Harold Elrod remodeled the Coffee Pot and added a dance hall. Local businessman Bob Radonich bought the restaurant and renamed it the Java Jive (from a song by the Ink Spots), by which name it is still known today. (TPL, BU-12497.)

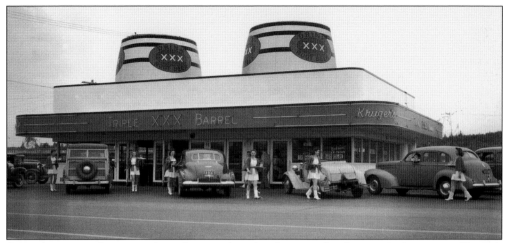

Six carhops attired in capes, short skirts, and cowboy boots are busily serving customers at Kruger's Triple XXX Root Beer Barrel drive-in at 3505 South Tacoma Way in this image from June 1941. The franchise's trademark barrels adorn the roof. Frank Kruger opened his restaurant in October 1936, after having operated a smaller Triple XXX Barrel elsewhere in Tacoma. The drive-in was sold to Bill and Thelma Busch in 1943. (TPL, D11401-3.)

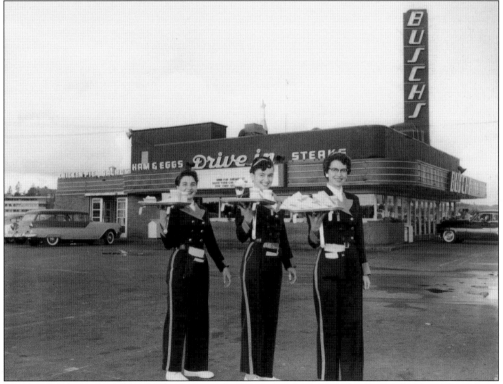

Carhop uniforms had drastically changed by the time of this October 1956 photograph of three young women laden with trays of food at Busch's Drive In at 3505 South Tacoma Way. After Bill and Thelma Busch purchased Kruger's Triple XXX Barrel Restaurant in 1943, the roofline was modified by removal of the giant barrels, and an impressive neon sign was erected over the entrance. (TPL, D102534-1.)

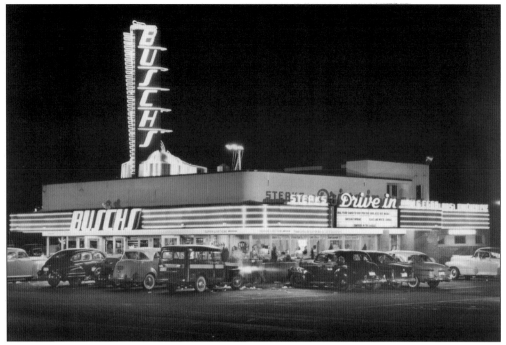

Busch's Drive In, aglow with neon and surrounded by shiny cars, was a spectacular sight at night. Though indoor seating was available, carhop service appealed to the "cruisers," who could remain in their cars while burgers, fries, and Cokes were delivered on trays that hooked on rolled-down windows. Drive-ins like Busch's became places to socialize as well as dine and helped fuel the car culture of the 1950s. (TPL, A58945-1.)

Camp Tahoma Cabins, 3836 South Tacoma Way, were among the earliest roadside accommodations on the Pacific Highway south of Tacoma. This view, dating from the late 1920s, shows seven of the 35 "clean, comfortable, electrically equipped cottages" arranged in a U shape; additional units were at the back of the property. With an on-site gas station, grocery, and lunchroom, Camp Tahoma was an early example of one-stop shopping.

This close-up shows the Standard Oil gas station at the Camp Tahoma cabins, where three gas pumps, Atlas tires and batteries, and the Standard Lubrication System were available to motorists. Located next to the cabins, (but artistically removed from the preceding photograph to emphasize the wooded surroundings) was Interstate Motor Sales at 3826 South Tacoma Way.

In keeping with the times, the camp went on to become the Tahoma Motel. The gas station had been removed by the time of this photograph, replaced by a towering neon sign, but the original cabins appear unchanged. The motel now boasted 36 units, 30 with kitchens, all with steam heat.

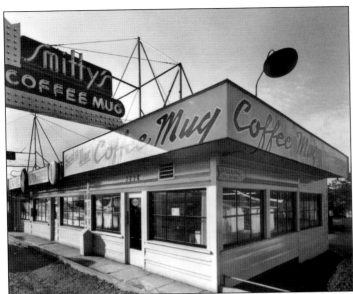

In the 1950s, Hugh O. Smith operated Smitty's Coffee Mug at 3838 South Tacoma Way, next door to the Tahoma Motel. In addition to coffee, the Coffee Mug featured a soda bar and ice cream. Customers could choose to sit in a booth or at the U-shaped counter. Smitty's later became Gail & Vern's Coffee Mug. Smith also owned Smitty's Drive In on Puyallup Avenue (TPL, A70619-1.)

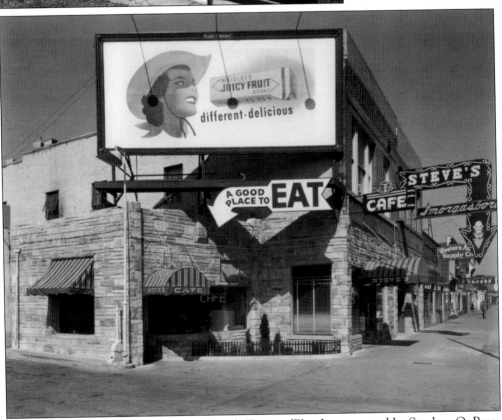

Steve's Café was a longtime fixture on South Tacoma Way. It was owned by Stephen O. Pease and John J. Stanley and featured "American dishes served in an atmosphere of the Gay 90's." The restaurant's décor included furniture and decorations salvaged from Tacoma's grand Victorian homes; entertainment included vaudeville routines and cancan dancing in the Opera House room. Later called Steve's Gay 90's, it closed in 1977. (TPL, A57331-36.)

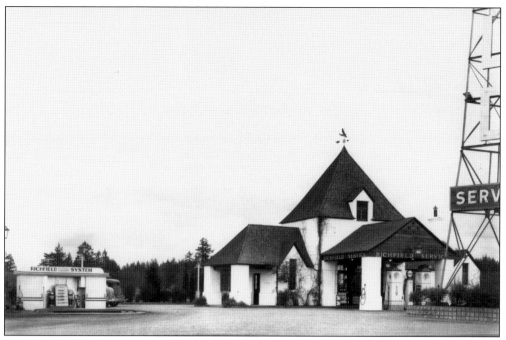

This Richfield Beacon Service Station at 8415 South Tacoma Way opened in July of 1930. Constructed in the French Normandy style, the station was part of a chain operating up and down the West Coast. An unusual feature was the adjacent 125-foot-tall tower; in addition to providing ample advertising space, two 8,000,000 candlepower beacons shone from its top. (TPL, A7012-4.)

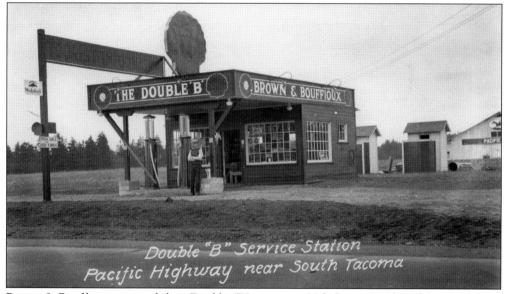

Brown & Bouffioux operated their Double "B" station at 86th Street South and South Tacoma Way when the latter was still called South Union Avenue. The station is a primitive-looking affair with two pumps, dirt drives, and outhouses at the rear. A change of gasoline brands has been made—the Shell sign is covered and a Mobiloil placard hangs from the post. The man is unidentified. (WSHS, 1957.280.258.5.)

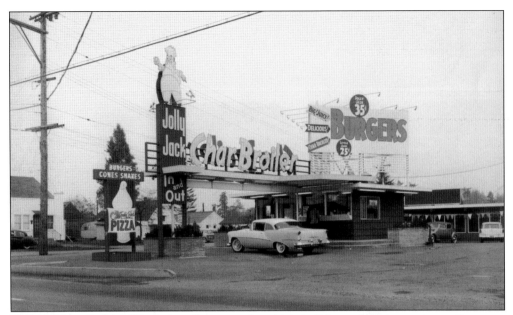

"Jolly Jack" was Jack M. Wood, the jolly man in the white chef's hat welcoming customers from atop the sign of his Jolly Jack Char Broiler at 8801 South Tacoma Way. In 1956, a charbroiled Jolly Jack burger cost 35¢; a Little Jack was only a quarter. Jack also served soft ice-cream cones, milk shakes, and freshly baked pizza. Jolly Jack's went out of business in the mid-1960s. (TPL, D102173-3.)

This is a 1946 view of the Motel Waltoma, located at 9200 South Tacoma Way. The motel was built in 1938 and took its name from owners Walt and Oma Kupfer. The Waltoma offered 16 ultramodern, fully equipped cottages with kitchenettes and garages and proudly displayed its Duncan Hines and AAA approval signs. Over 2,500 persons attended its grand opening in July 1938. The site is now a mini-mall. (TPL, 7003.)

Opened in the early 1960s, the Rose Motel was located at 9021 South Tacoma Way and represents a newer, more modern era of lodging than does the Waltoma, just across the street. The owners proudly claimed they offered hot water heat, telephones, radios, and televisions in every unit. This section of Highway 99 was soon to be bypassed by freeway construction, however. The site is now home to the Golden Lion Inn.

The "completely modern" Motel El Rancho was located at 9325 South Tacoma Way. The El Rancho was owned by Harold Hunnicutt and featured a towering neon sign, complete with horse and rider. Steam heat, tubs, stall showers, and locked garages were standard; kitchenettes were available "if you like." The El Rancho was a member of United Motor Courts and was recommended by AAA and Duncan Hines. (TPL, D100058-1.)

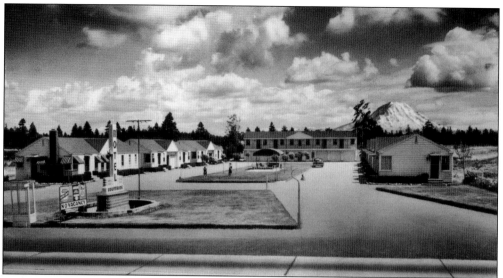

With the spectacular background of Mount Rainier and a cloudy sky, this view of Motel Fountaine ("It's Quiet—Try It!") shows the classic U-shaped configuration of tourist courts of its era. Two people appear to be playing croquet on the grassy area, and the signs out front display the Fountaine's United Motor Courts and Duncan Hines recommendations. The motel was located at 9915 South Tacoma Way. (TPL, C23655-1.)

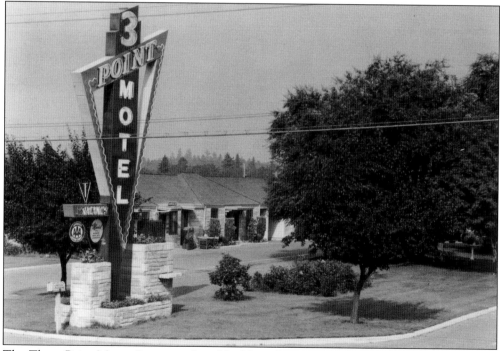

The Three Point Motor Court was listed by United Motor Courts as early as 1941. By 1954, when it was owned by Ruth and Fred Haman, it had been renamed the 3 Point Motel. Located at 10117 South Tacoma Way, the motel's prominent neon sign beckoned travelers to enjoy such amenities as ceramic tiled showers, electric kitchens, central hot water heat, and Jetco coffee service. (TPL, A83102-1.)

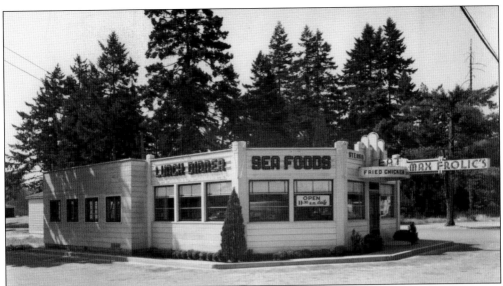

This Art Deco–style roadside eatery was opened by entertainer Max Frolic in 1938 in partnership with William Thornburg. Their slogan: "Our specialty: Steak or Chicken Dinners . . . Suggest 'Frolic's' when you are in this neighborhood—A fine meal reasonably priced." The restaurant underwent a major remodel, added a new dining room, and celebrated its grand reopening in June 1958. The building is still standing. (TPL, A83102-1.)

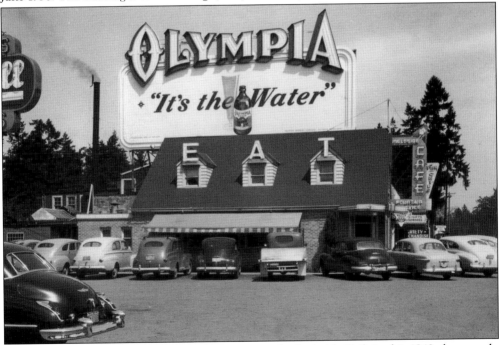

An Olympia beer sign ("It's the Water") towers over the Ingleside Cafe in this 1949 photograph. Located not far from the main entrance to Fort Lewis at 12914 Pacific Highway Southwest in Lakewood, the café was built on the site of a famous roadhouse called Ingleside Sunken Gardens, which had been destroyed by fire in 1936. Letters on the dormer windows invited passersby to E-A-T fish and chips and enjoy fountain service. (TPL, D42402-1.)

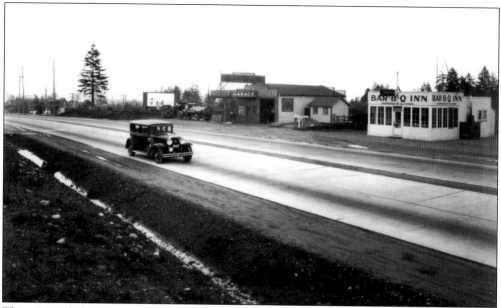

This view is believed to be of the Pacific Highway at Tillicum looking west. Fort (then Camp) Lewis would be behind the camera; telephone and power poles can be seen marking the line of the railroad behind the buildings. The Bar-B-Q Inn offered sandwiches "of all kinds"; Kennedy's Garage dispensed gasoline and oil and performed light auto repairs. An early tanker truck can be seen parked at the garage. (TPL, 7007.)

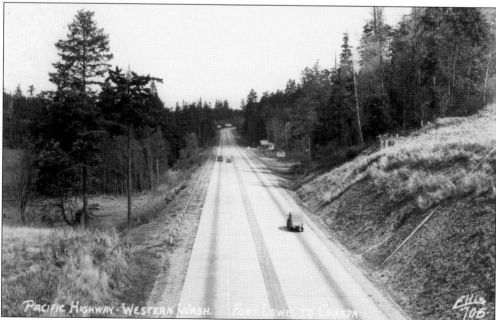

A newly constructed segment of Highway 99 drops into the Nisqually River valley south of Tacoma—with four lanes and hardly any traffic, it was a wonderland for the modern motorist. The situation was too good to last, though; today, the highway (now incorporated into Interstate 5) is as traffic-choked as any in the nation. This section of road bypassed an earlier alignment that followed the river before turning through Lacey into Olympia.

The Lodoro Motel, located a mile northeast of downtown Olympia at 3434 Martin Way E, was built for C.E. Nyland in 1939 and expanded in 1945. The motel featured 18 deluxe units (some with kitchens) and all the modern conveniences: steam heat, tiled tubs and showers, wall-to-wall carpeting, telephones, television, and garages. Both Duncan Hines and AAA placed their stamp of approval on the Lodoro.

Across Highway 99 from the Lodoro was the Bailey Motel at 3333 Martin Way E, which opened with 15 units in 1946 and expanded to 32 units in 1953. The motel was owned by Mr. and Mrs. H.B. Bailey and advertised itself as "the traveling man's home" with a coffee shop on the premises. Bailey's was part of the Best Western chain and still serves travelers as Bailey's Motor Inn.

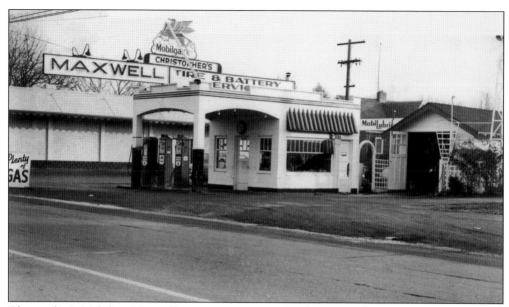

Christopher's Mobilgas Maxwell station was at 1931 E 4th Street, three-fourths of a mile from downtown Olympia. Mobil's signature flying horse was displayed above the columned portico; three gas pumps stood ready to provide fill-ups. A small wooden garage for repairs (seen with its doors wide open) adjoined the station. At the time this photograph was taken, Christopher's had plenty of gas but no customers. (TPL, 111-080.)

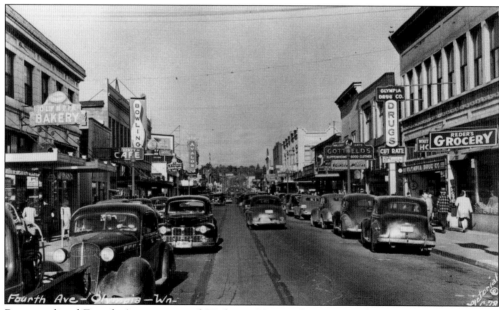

Busy, car-lined Fourth Avenue carried Highway 99 into downtown Olympia in 1947. Visible in the right-hand side of this image are signs for the Olympia Bakery, Liberty Café, a bowling alley, the Franklin Hotel, and the Avalon Theatre. On the other side of the street are Reder's Grocery, Olympia Drug Company, Gottfeld's (a men's clothing store), and Karl's Shoes. (TPL, CAM-26.)

Five

OLYMPIA TO VANCOUVER

Highway 99 turned south at the intersection of 4th Avenue E and Capitol Way in downtown Olympia. Proceeding through Tumwater, the next town was Tenino (12 miles), then Centralia (another 15 miles), and Chehalis (four miles farther on). Services were scarce along the 23 miles of Jackson Highway (as it is locally known) between Chehalis and Toledo, with only a few cafés and service stations found at Dorn's Corner and Mary's Corner. At Toledo, the highway crossed the Cowlitz River on its way to Castle Rock, 14 miles distant. Another 10 miles brought the traveler to Kelso.

Five miles south of Kelso, the highway came in sight of the Columbia River and stayed close to it through Kalama, only to head inland again through Woodland and La Center. At La Center, the highway wound up through hills for a few miles before making a virtual beeline for Vancouver and the Interstate Bridge to Oregon, 17 miles away.

As early as the 1940s, the two-lane highway was being bypassed by new construction pushing north from Vancouver. A direct route between Vancouver and Woodland was in place by the 1950s, leaving La Center off the main highway. The new four-lane skirted Woodland, passed through Kalama (taking much of downtown with it), and bypassed Kelso and Castle Rock. North of Castle Rock, the four-lane made a direct line north, edged around Chehalis and Centralia, then headed to Olympia. Toledo and Tenino were no longer on the mainline.

From Olympia all the way south to Vancouver, Highway 99's route remains close to the alignment of the Pacific Highway as laid out in the early 1920s. There are a few spots where the old highway intersects Interstate 5, and under/overpasses have been constructed in conformance with modern highway engineering practice. A four-mile stretch of "99" is under the freeway between Kalama and Woodland, but otherwise most of the original route is intact and easily driven.

Resplendent with neon signs displaying its namesake bird, Clark's Crane Cafe was located at 407 Capitol Way in downtown Olympia. At the corner of 4th Avenue and Capitol Way, just a few yards away, Highway 99 turned south, having entered the city via 4th Avenue East. A 58¢ breakfast special was available at Crane's on the day this photograph was taken. (WSHS, C1986.36.108.)

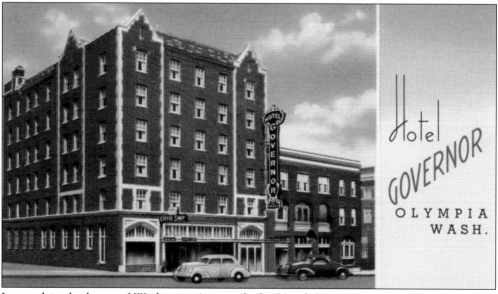

Located in the heart of Washington's capital, the Hotel Governor was among the upscale accommodations along the Pacific Highway. The six-story building, with its prominent neon sign and on-site coffee shop, catered to highway travelers as well as those on official business. The original hotel has been torn down; a replacement of the same name now occupies the site.

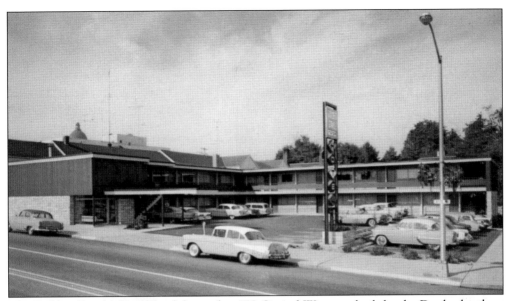

The Golden Gavel Motor Hotel, located at 909 Capitol Way, was built by the Dawley brothers between 1957 and 1958. With 27 units, each having extra-long beds, separate sleeping and dressing areas, and free TV, it was among the most well-appointed accommodations in Olympia. The "Golden Gavel" refers to the opening of the legislature at the State Capitol building, seen peaking above the motel's roof. It has been renamed the Olympia Inn.

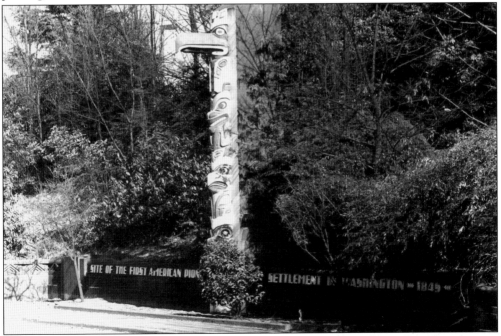

The Capitol Way Bridge was ornamented Art Deco style, displaying fancy railings and streets lights, as well as four totem poles (two on each side of the highway near the ends of the bridge). Each of the totems, cast in concrete by the Olympian Stone Company of Seattle, has an inscription celebrating Tumwater's claim to being both the end of the Oregon Trail and the first pioneer settlement in the state. (WSDOT.)

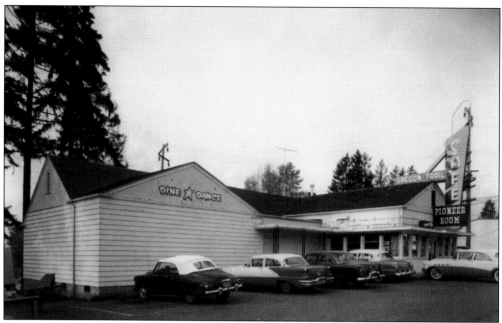

The Oregon Trail Inn claimed to be the end of the old Oregon Trail. Located just north of the Olympia Brewery at 3507 Capitol Boulevard in Tumwater, the restaurant specialized in steaks, seafood, fried chicken, and chuckwagon-style dining; dancing and cocktails were offered in the Pioneer Room. Today, the building is home to the South Pacific Restaurant. (TPL, D102820-5.)

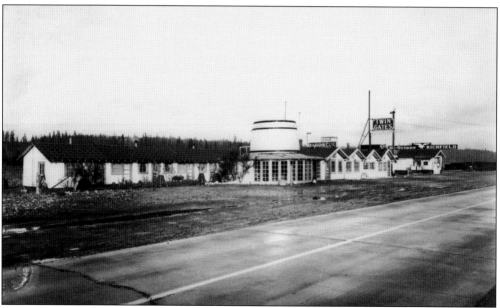

The Twin Gates Barbecue opened in June 1926, and for years was a famous stopping point on the Pacific Highway three miles west of Tenino. The owners, the Bluhm family, expanded the café in 1935 with extra seating capacity and a ballroom. The barrel housed an elegant banquet hall. A service station and Red Cross first aid station operated in connection with the restaurant—this stretch of highway was notoriously accident-prone. (TPL, B25737.)

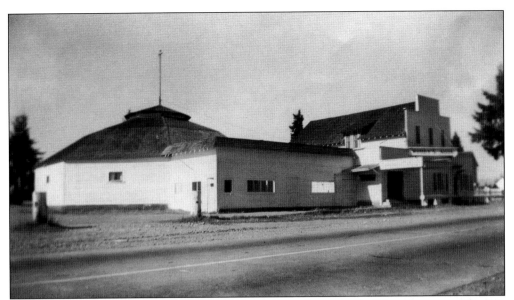

Looking like a scene from a Western mining town, the collection of buildings known as Woody's Nook was located a couple of miles north of Centralia, at Grand Mound. The dance hall was opened in the early 1930s by A.A. Woodfield, a local orchestra leader and dance hall promoter. Despite its rather rough appearance, Woody's was known for good, clean fun. (LCHM, P10478.)

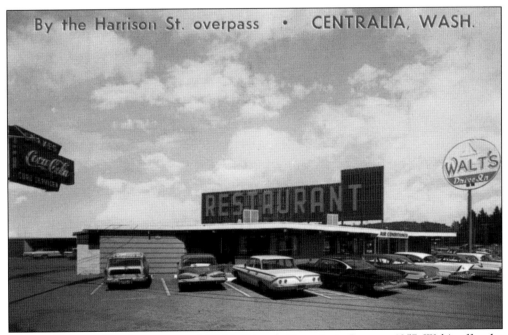

Walt and Marion Henderson opened Walt's Triangle Drive-In in January 1957. Walt's offered a dining room, coffee shop, and curb service with "electronic telephones." In addition to hamburgers and fries, breakfast was served all day. The restaurant was located on the "old highway" but was adjacent to the newly constructed four-lane that bypassed downtown Centralia and would eventually become Interstate 5.

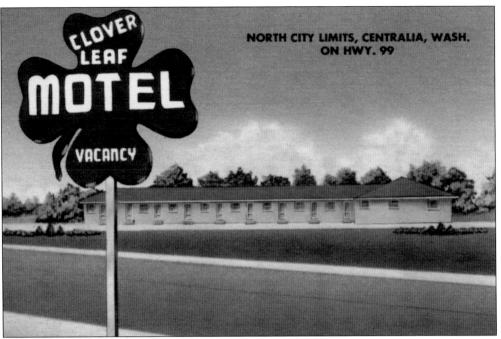

The Clover Leaf Motel opened around 1953 at 2100 Harrison Avenue, 2.5 miles north of downtown Centralia. Radiant heat and Seeley mattresses were featured; radios were furnished without charge. The Cover Leaf's timing was ideal; though the motel was originally built out in what was considered the country, the "99 expressway" (the future Interstate 5) would pass right next to it within a few years.

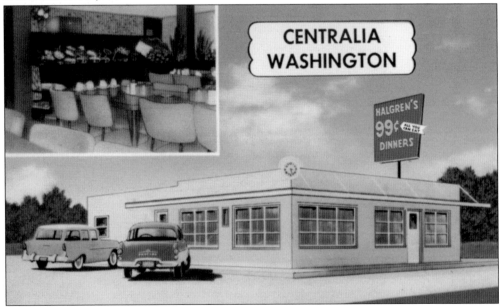

Bill Manning opened the Chickburger Inn in August 1941, at 1001 S Gold Street in Centralia. Described as "the only curb service restaurant between Vancouver and Tacoma," it expanded over the years to become a sit-down restaurant with an adjacent motel. By 1958, Gunnar and Ruth Halgren had purchased the business and renamed it Halgren's All You Can Eat 99¢ Dinners.

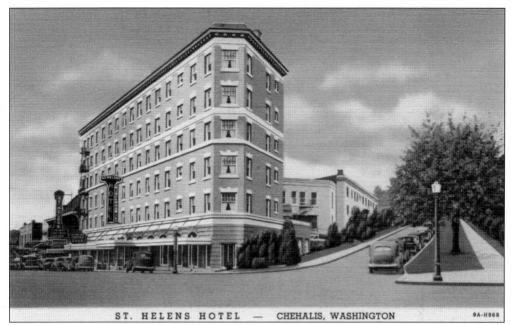

ST. HELENS HOTEL — CHEHALIS, WASHINGTON 9A-H868

The St. Helens Hotel in Chehalis, located halfway between Seattle and Portland, Oregon, was completed in 1920 as traffic began to significantly increase on the Pacific Highway. With a coffee shop on the premises and service stations nearby, the St. Helens offered upscale accommodations compared to those found at the sometimes-primitive auto camps elsewhere on the route.

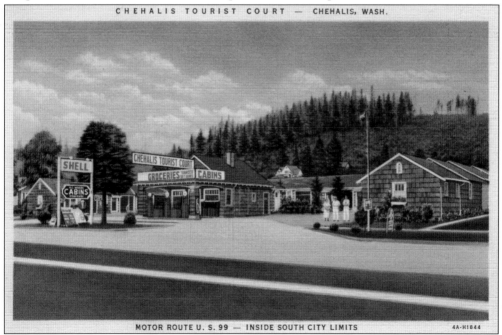

CHEHALIS TOURIST COURT — CHEHALIS, WASH.

MOTOR ROUTE U. S. 99 — INSIDE SOUTH CITY LIMITS 4A-H1844

The Pacific Highway ran through 30 miles of rolling pastures and wooded hills between Chehalis and Castle Rock, the next large town on the route. The Chehalis Motor Court, at the south edge of the city, was a full-service operation with cabins ("neat as a pin"), gas station, and store, of which motorists could avail themselves before beginning this somewhat lonely stretch of road.

For over 75 years, Mary McCrank's dinner house has been a landmark south of Chehalis. Originally named the Dutch Mill, it became the Shamrock Inn by 1935 when Mary took over. The inn prided itself on comfort and warmth, featuring antique furnishings; plates; and silverware; and, of course, good food. The Schopp family has owned the restaurant since 1998. (JCO'D.)

Mary's Corner, a crossroads located about 11 miles south of Chehalis, supported a cluster of businesses, including the Mary's Corner Café (seen here). The café offered meals, fountain service, and groceries, as well as gasoline and light auto repairs. The Mary's Corner Motel was just down the road. This stretch of road is called the Jackson Highway.

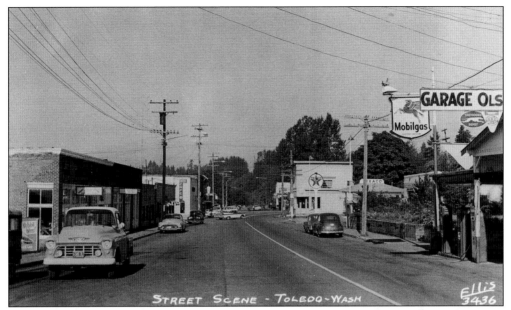

After nearly 25 miles of farmland, rolling hills, tall trees, and few houses, the traveler arrived at Toledo, on the Cowlitz River. Though a small town when the highway was built, the gas stations and other services on Toledo's main thoroughfare were a welcome sight. This length of the Pacific Highway was notorious for being muddy and difficult before being paved around 1926—the last section to be completed. (JCO'D.)

By the 1950s, realignments of Highway 99 were leaving smaller towns off the main route. Businesses like the Cowlitz Motel built out on the new highway, where land was cheap and competition was scarce. The motel was right on the Cowlitz River and promised newly furnished units, coffee in the lobby, and good food next door.

140 M. SO. OF SEATTLE. "THE TOURISTS MECCA" 68 M. NO. OF PORTLAND. 120722

Toutle River Auto Camp was located near the confluence of the Toutle and Cowlitz Rivers, about three miles north of Castle Rock. About a dozen cabins, a commons building, and a children's playground on the banks of the river can be seen in this view, with the Pacific Highway passing by on the right. A portion of the camp still exists.

MAGGARD'S PARK, 1 MILE NORTH CASTLE ROCK, WASH. 1A48

Maggard's Park was another example of 1920s tourist court architecture. It was nestled in a grove of tall trees a mile north of Castle Rock and featured 29 cabins with brightly colored shingle roofs, a store, a café, and a gas station. With an adjacent lake for swimming and the Toutle and Cowlitz Rivers nearby, Maggard's offered recreation for both travelers and locals.

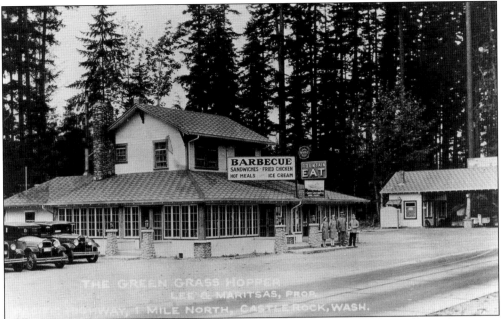

The Green Grasshopper was a dine-and-dance place located a mile north of Castle Rock in the early days of the Pacific Highway. The roadhouse had a large, porch-like dining area built around what appears to be a residence. The menu featured chicken dinners as well as fountain treats and barbecue sandwiches. A gas station operated next door. The Green Grasshopper was still in business in 1931. (CCHM, 1991.0062.0002.)

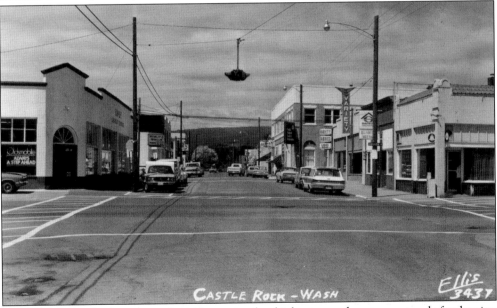

Castle Rock was the first town of significant size that highway travelers encountered after leaving Chehalis, 30 miles up the road. In this view looking west, Highway 99 (locally called Huntington Avenue) passes from right to left. Downtown Castle Rock sits slightly off the highway, although an earlier alignment via Front Street routed through the business district. The town was completely bypassed by a four-lane highway in the 1950s.

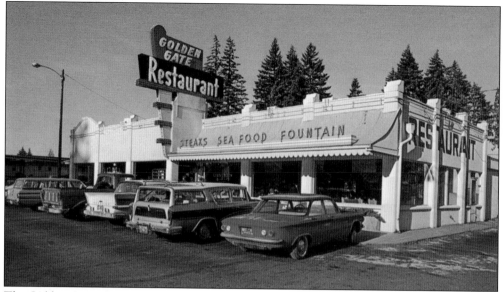

The Golden Gate Restaurant occupied an Art Deco–style building a mile north of Kelso, on the west side of the highway that bypassed the town in the late 1940s. Howard and Dorothy Robinson operated the restaurant and promised comfortable surroundings for leisurely dining, as well as quick, courteous service for travelers on the go. Specialties included seafood, steaks, and chicken; banquet facilities were available.

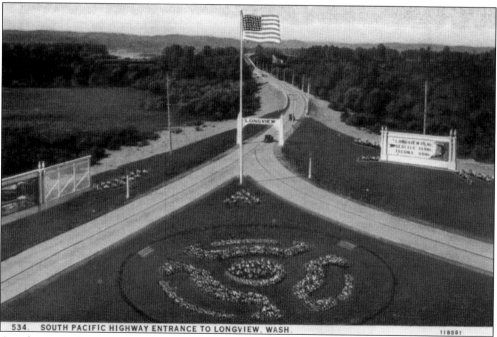

534. SOUTH PACIFIC HIGHWAY ENTRANCE TO LONGVIEW, WASH.

A welcome arch; a tall, proudly waving flag; and a beautiful floral garden greeted northbound motorists near Longview in the early days of the highway. Fancy streetlights can be seen lining the road heading into the city. Later alignments bypassed Longview in favor of a route through Kelso, a few miles to the east. The site of this idyllic scene has long since been disturbed by interstate freeway construction.

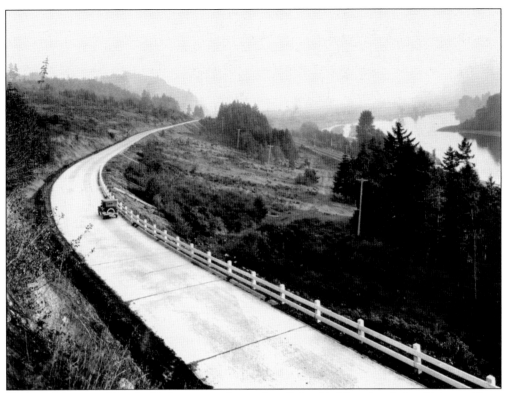

The concrete-paved Pacific Highway met the mighty Columbia River just below Kelso and kept close to it for several miles. This view looks south from a point south of Kalama, with Woodland off in the distance. A few remnants of this stretch of highway can be found, but most of it has disappeared underneath Interstate 5. (CCHM, 1970.0056.0034.)

Divided Highway 99 approaches Woodland in this northward view from around 1950; the town was just off the highway, behind the photographer. Signs for Texaco, Signal, and Mobilgas service stations and the Arrow Motor Court welcomed the motorist. A quarter mile north of Woodland (approximately where this photograph was taken), the highway turned sharply to the east to cross the Lewis River, which it followed toward La Center. (WSHS, 2001.13.25.)

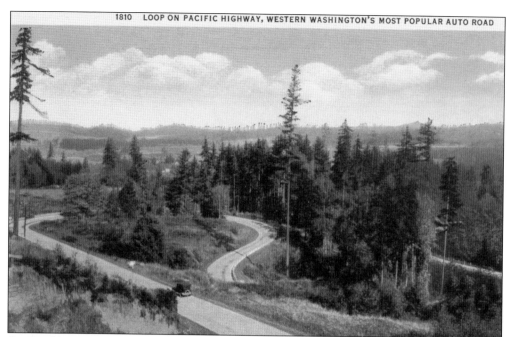

South of La Center, the Pacific Highway took to the hills to reach the high prairie leading to Vancouver. An altitude gain of nearly 300 feet within half a mile was accomplished by these hairpin turns, which at times were so tight that the highway nearly doubled back on itself. An early realignment of Highway 99 eliminated this torturous climb, but much of the loop still exists as secondary roads.

Billing itself as "not the largest, but one of the best," Davies Motel was located five miles north of Vancouver in a rural setting at 13408 Highway 99. Davies offered Beautyrest mattresses, hot water heat, and tile showers. A 24-hour café and service station adjoined the motel. When C.A. Stringfellow purchased the property, he renamed it the 99 Motel.

124

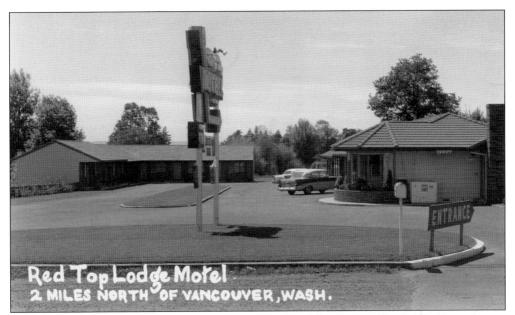

The AAA-recommended Red Top Lodge Motel offered 14 deluxe units, all with television, phones, electric heat, and wall-to-wall carpeting. Guests could enjoy coffee service and free ice. Family units were available as well as a play area for children. The motel's location at 8012 Highway 99 north of Vancouver, once surrounded by trees, is now heavily developed.

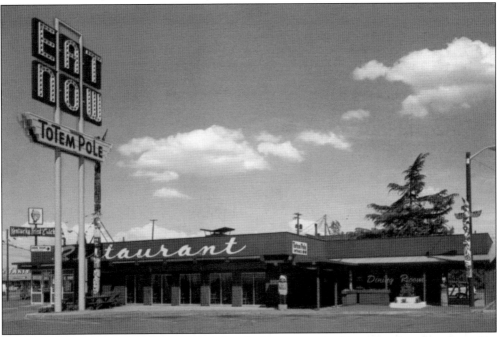

Legend says the Totem Pole Inn originated with the pioneer Anderson family, whose log cabin served wayfarers on the trail north from Vancouver. When the Pacific Highway built through in 1929, the cabin was updated to accommodate motorists. Here, longtime owner George Goodrich introduced Kentucky Fried Chicken to the northwest. Claimed as the state's oldest restaurant to remain in its original location, the Totem Pole Inn closed in August 1998.

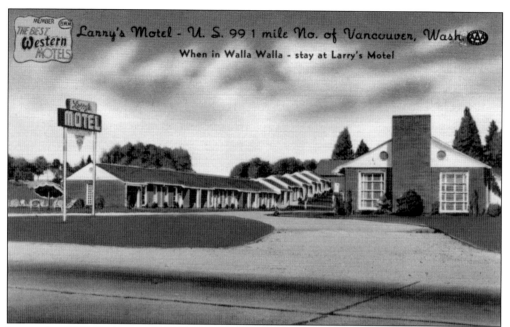

Located at 7017 Highway 99, Larry's Motel consisted of 24 elegantly furnished, "roomy" units arranged in two rows on the gentle slope of a wooded hillside. Rooms were available by the day, week, or month; all were carpeted, some had fireplaces and locked garages. The pool was out by the highway. Reminiscent of early days of auto camping, Larry's had a community kitchen. Larry also operated a motel in Walla Walla.

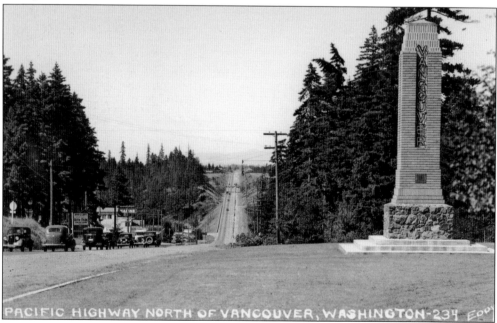

The Pacific Highway approaches Vancouver from the north. Oddly, the highway appears to consist of two paved lanes and a dirt shoulder wide enough to be an additional lane; perhaps the highway was being widened. Signs can be seen for the Wild Rose Auto Park and a service station at the bottom of the hill. The Pioneer Memorial welcomed visitors; it is still there.

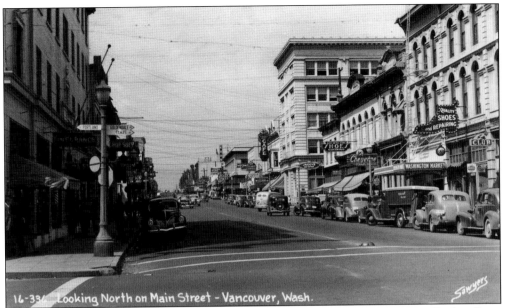

16-336 Looking North on Main Street - Vancouver, Wash.

Highway 99 passed down Vancouver's busy Main Street on its way to the Interstate Bridge. Signs for Quality Shoes and Repairing, the Cheyenne cigar store, Jaggy's Fine Footwear, and the Oyster Loaf Restaurant can be seen on the east side of the street. On the other side were a chop suey house, an AAA office, and drug and hardware stores. The tower of radio station KVAN is up the street.

INTERSTATE BRIDGE - VANCOUVER, WASH.

The Interstate Bridge, spanning the Columbia River between Vancouver and Portland, Oregon, opened to traffic in 1917 as a single bridge carrying two-way traffic. The bridge consisted of 13 steel spans, one of them being a lift span to allow river traffic to pass underneath. A second, twin bridge opened in 1958, allowing each bridge to carry one-way traffic. The northbound bridge is the original 1917 structure.

DISCOVER THOUSANDS OF LOCAL HISTORY BOOKS FEATURING MILLIONS OF VINTAGE IMAGES

Arcadia Publishing, the leading local history publisher in the United States, is committed to making history accessible and meaningful through publishing books that celebrate and preserve the heritage of America's people and places.

Find more books like this at
www.arcadiapublishing.com

Search for your hometown history, your old stomping grounds, and even your favorite sports team.